In Search of **Mary Magdalene:** Images and Traditions

Diane Apostolos-Cappadona

In Search of Mary Magdalene
$20.00

This catalogue accompanies the exhibition
In Search of Mary Magdalene: Images and Traditions,
on display from April 5–June 22, 2002,
at The Gallery at the American Bible Society.
1865 Broadway (at 61st Street)
New York, New York, 10023
www.americanbible.org
212.408.1500 PHONE
212.408.1456 FAX

This exhibition was curated by
Dr. Diane Apostolos-Cappadona and organized at the
American Bible Society by Patricia Pongracz and Ute Schmid.
Catalogue published by the American Bible Society.

Catalogue designed and produced by Vincent Lisi
and Annie McConnaha, Two Dogs Design.
Exhibition designed by Thomas Moran.
Printed in the United States by Frantz Lithographic Services, Inc.
Typeset in Monotype Centaur, Monotype Grotesque and
Goudy Cloister Initials.

Front Cover: Carlo Dolci (Italian, 1616–1687)
The Penitent Magdalen (detail), c. 1670
Oil on canvas
Museum Purchase, 1958.19
Davis Museum and Cultural Center
Wellesley College, Wellesley, MA

Back Cover: Gustave Doré (French, 1832–1883)
Woman Taken in Adultery (detail)
From *The Doré Bible Gallery*
New York: Fine Art Publishing Co., 1879
The Library at the American Bible Society

ITEM 112429
ISBN 1-58516-645-6

Contents

Acknowledgements

The gathering of materials for both this exhibition and this catalogue depended upon the generosity and cooperation of many organizations and individuals. Foremost among these was Ena Heller, who it was my good fortune to encounter as she embarked on her tenure as Director of The Gallery at the American Bible Society. Every task from the clearing of loan requests to this publication has been attended to with care and diligence by Patricia Pongracz, Curator; Ute Schmid, Curatorial Assistant; and Kim Aycox, Gallery Assistant.

I am pleased to have this opportunity to thank every lender as well as all the librarians involved in my search for Mary Magdalene. Although they are too numerous to list, I hope they accept the sincerity of this collective note of thanks. My gratitude extends to the staff of the American Bible Society who added editorial perspective to my text, and to the owners of the works of art illustrating this catalogue. The earlier scholars who have searched for Mary Magdalene have been my foundation. Their achievements are noted here in the selected bibliography.

Authors with learned friends receive a special gift when they witness their friendship in the sharing of knowledge. I am privileged to acknowledge Erika Langmuir and Joseph N. Tylenda, S. J., for their invaluable counsel in my writing for this catalogue. My parents continue in their familiar roles of constant and steadfast support for a life lived in the academic world. As with every publication, lecture, or award, my deepest personal and scholarly obligation remains with Laurence Pereira Leite who introduced me to the exhilarating study of Christian iconography and who guided my first research on Mary Magdalene.

DIANE APOSTOLOS-CAPPADONA
Georgetown University

Preface

For almost 2000 years artists have made the Word visible. Since the early Christian era, biblical stories have been depicted in various media. Successive generations of artists have created images that respond to the needs and trends of their own time. Traditions evolved and grew richer over time, each age learning from its predecessors and informing its followers. Charting the course of an image, person or event drawn from Scripture is a fascinating journey through history, as the exhibition *In Search of Mary Magdalene: Images and Traditions* richly illustrates.

The works assembled in the Gallery reveal that. Despite the limited, but clear references to her in the Bible, Mary Magdalene has been depicted in a variety of ways with each of her "images" visually defined. Dr. Diane Apostolos-Cappadona, the curator of the exhibition, suggests that the Magdalene's many permutations may find root in scriptural (mis)interpretation, the writings of church fathers and notable theologians over time. In so doing, she demonstrates the active dialogue between textual and visual interpretation: while the text of the Scriptures informed artistic representations, they in turn left their mark on later literary sources. The exhibition thus helps us separate biblical truth from later traditions, both visual and textual.

The American Bible Society is grateful to the many individuals who made this exhibition possible. First and foremost, we thank our guest curator Dr. Diane Apostolos-Cappadona for sharing her knowledge on the subject of Mary Magdalene. We are grateful to the institutions and individuals who generously let their works travel to New York City for this exhibition. At the American Bible Society, Dr. Ena Heller, Director, Patricia Pongracz, Curator, and Ute Schmid, Curatorial Assistant, facilitated the organization of the exhibition, while Kim Aycox, Gallery Assistant, assisted them whenever necessary. Dr. David Burke, Dean of the Nida Institute for Biblical Studies, offered critical scriptural insights to the catalogue, while Peter Feuerherd edited all written materials. Dr. Liana Lupas, Curator of the Scripture Collection at the American Bible Society Library, provided invaluable information for the books on display. Thomas Moran designed the exhibition and Vincent Lisi and Annie McConnaha, of Two Dogs Design, gave it graphic identity.

We hope that this exhibition and accompanying catalogue will contribute to our understanding of the fascinating figure of Mary Magdalene, as revealed in Scripture and embraced by artists through the centuries.

EUGENE HABECKER, Ph.D.
President

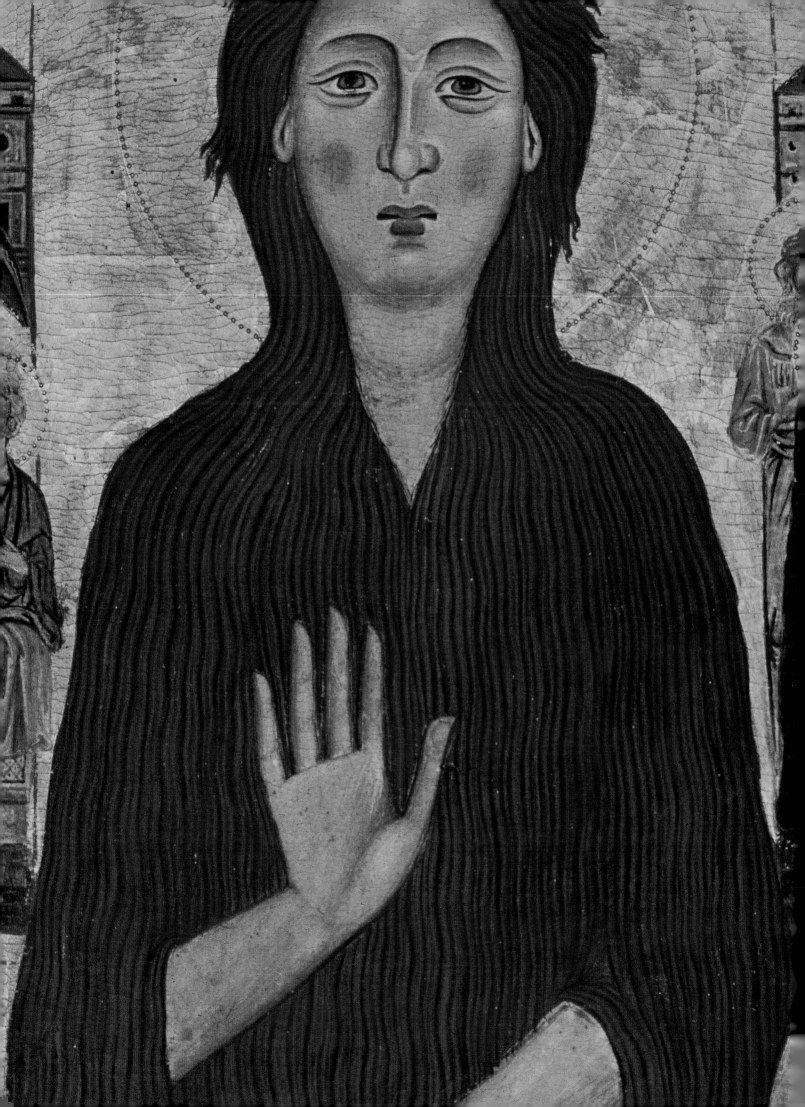

In Search of Mary Magdalene

S HE HAS given her name to societal categories of women from repentant sinners and morally reprehensible "fallen women" to melancholy paragons of religious devotions; to social institutions such as asylums caring for unwed mothers or reformed prostitutes; to educational establishments such as colleges and libraries; and even to an adjective characterizing its subject as foolishly or excessively sentimental. She is portrayed as a glamor girl, a weeper, a matron, a protectress, a contemplative, and a hag. She is entreated by cloistered nuns,

couturiers, women in childbirth, infertile women, mourning mothers, unmarried girls, flagellants, philosophers, and penitents of all descriptions. She is sinner, penitent, witness, contemplative, and muse; and she is also saint. She is the topic of immeasurable works of legendary and pious devotion, theological investigation, societal debate, and spiritual reflection as well as works of art throughout the twenty centuries of Christianity. Who she is is almost impossible to say; how she came to be formidable to explain entails an arduous journey through a matrix of oral and written traditions, theology, spirituality, ritual, mythology, art, culture, values, and the human psyche. That she is all of these is more reasonable to examine.

My search for Mary Magdalene as sinner, penitent, witness, contemplative, and muse traverses the coalitions, confusions, and conflations of image and story. Although the scriptures are clear in their definition of Mary Magdalene, her story and persona have become muddled over the centuries in the hearts and minds of believers. Many of her identifications, especially with the anonymous scriptural women, derive from early ecclesiastical authors, and influence both artists and the Christian collective. This essay provides an overview of the scriptural transformations, patristic reinterpretations, and legendary stories critical to the shaping of the Magdalene's iconography. The individual iconographic entries— sinner, penitent, witness, contemplative, and muse—clarify artistic innovations and theological revisions.

From her origins as the first witness to the Resurrection of Jesus Christ and the first female penitent through her journey as one of the most popular saints in Christian history, the Magdalene has exhibited complexity and flexibility in her definitions, evolutions, and transformations. In codifying faith by "telling stories in pictures" and in simplifying theology by removing non-essential conundrums, images offer a concentrated and clearly defined corpus of human attitudes throughout history. Mary Magdalene engages and compels our attention as her images resonate with the celebrations and afflic-

Figure 1. Magdalene Master (13th century)
LA MADDALENA E STORIE DELLA SUA VITA
Copyright Scala/Art Resource, NY
Accademia, Florence, Italy

tions of the religious mythologies, cultural postures, grandiloquent allegories and sermons, and stereotypes which she has come to encompass.

Recent scholarship, including religious studies and church history, has recognized the importance of "the visual" as primary evidence for a critical understanding of history. Without doubt, we know that the majority of people even into the twentieth century were textually illiterate but visually literate. The symbolism of Christian art was premised upon the visual literacy of those who *looked* at the images, motifs, and symbols. Thereby, to understand the meaning of an event or a person such as Mary Magdalene, we must *look* at the history of her iconography and incorporate what we learn from *looking* into the frame of scriptural tradition, devotionalism, pious legend, and practical tradition. With this new attitude—acknowledging the importance of visual images as equal to textual documentations—and the concomitant questioning of preconceptions, we must concern ourselves with the crucial and *not* easily answerable question: how and why did the acknowledged first witness to the Resurrection become so totally identified as the reformed prostitute?

The woman known as Mary Magdalene has been popular with believers from the earliest Christian times. By the fourth century, she had become a role model for female believers and an identifiable artistic element in both religious narrative and personal devotion. During the early Middle Ages, Mary Magdalene garnered one of the most varied legendary and artistic iconographies of all Christian saints as exemplified in *La Maddalena e storie della sua vita* (fig. 1). This early thirteenth-century visual testimony to the importance of her cult includes scriptural episodes—Anointing at Bethany, Raising of Lazarus, *Noli Me Tangere*, and her preaching mission—in the upper registers; and pious traditions surrounding her penitential life in France in the lower registers. Her monumental central figure affirms the fusion of the Magdalene with the other reformed prostitute saint of early Christianity: Mary of Egypt. As with Donatello's fifteenth-century sculptural masterpiece, *La Maddalena*, the characterization of the once elegantly attired and coiffed beauty as a gaunt and wasted figure covered only by ragged pelts and her long-flowing hair proceeded from the iconography of the Desert Mothers and the extreme asceticism of repentant sinners such as Mary of Egypt. This barefooted, scroll-carrying woman appears far removed from the first witness as she stands as the object of the viewer's gaze.

Mary Magdalene had distinctively different personae for the lay faithful and theologians. A survey of her iconography in western Christian art demonstrates that the earliest depictions of the Magdalene in artistic and dramatic narratives were as *the* first witness of the Resurrection and apostle to the apostles. Medieval and Renaissance portrayals expanded to include the varied episodes of her Life, Penance, Last Communion, and Elevation. This visual evolution mirrored the rise of her importance in Christian spirituality from a historical role in the life of Jesus of Nazareth into that of the archetypal penitential saint who signified the centrality of the sacraments. During the Early Modern period, she became the spiritual and visual defender of the sacraments of the Roman Catholic tradition, while retaining a role as the female penitent in the Protestant traditions. In the nineteenth century, she was transformed into a *femme fatale* and courtesan "with a heart of gold," while twentieth-century artists have emphasized the multiplicity of her religious personae especially that of the reformed prostitute. Mary Magdalene is a classic image of the redemptive and transformative nature of Christian faith. The Christian believer finds him/herself closer to accepting the reality of the otherwise abstract concepts of sin and forgiveness as concrete human realities through the story and imagery of the Magdalene. She has come to represent visually and spiritually the fullness of the human experience in her journey from sinner to saint.

Nonetheless the question remains: who was Mary Magdalene and how did she come to have such a significant spiritual and artistic influence in Christianity and in secular culture? There have been distinctive "approaches" to the Magdalene from her varied audiences: theologians, biblical scholars, art historians, feminists, liturgists, church historians, and believers. My search for Mary Magdalene is complex, multivalent, and heuristic in that every explanation leads to a new question. The fusion of theology, scripture, liturgy, devotionalism, gender, society, culture, and indigenous traditions which combine in her story and imagery affirm that the fundamental character of her uniqueness is the "mystery" of her ambiguity and complexity.

My search for Mary Magdalene references motifs in which art history and theology are mutually fructifying. The patterns of sinner, penitent, witness, contemplative, and muse, though not comprehensive,

suggest who Mary Magdalene is within the contexts of the Christian traditions. Image and story work in unison to harmonize and to clarify religious tradition. Story blends personal and communal history as it explains the origin, meaning, and destiny of Mary Magdalene for both the Christian faith and culture. Image combines subject with object as it translates narrative into a reality revelatory of unexpected meanings and truths. Although not univocal or linear, but rather affective and cognitive, images are principal historical witnesses in the study of Christian theology and culture. Taken together, image and story elicit a religious response in reflecting on who we are and what we hold to have meaning and value.

Art, culture, and values are historically conditioned. Therefore, my exploration of the transformations of

Mary Magdalene's identity, roles, and imagery is premised upon three ideas which relate "faith" with "culture" throughout Christianity's twenty centuries: metanoia, unction, and metamorphosis. Metanoia is the state of profound regret over actions, thoughts, or intentions which leads to a conversion in a person's heart, behavior, or thoughts; it is repentance. Unction is the act of anointing for either medical purposes or the religious ritual of consecration; the seal of spiritual healing and protection. Metamorphosis is the transformation from one form into another. Thereby, the coordination of metanoia, unction, and metamorphosis is evidenced by Mary Magdalene. Conversion leads to healing, anointment is the sacred seal of that consolation, and together conversion and anointment bring about metamorphosis, or in the case of the Magdalene throughout the centuries, metamorphoses.

In Search of Mary Magdalene: Scripture Sources

ARY MAGDALENE'S story and image begin in the Christian Scriptures. Unfortunately, even the most careful readings of Matthew, Mark, Luke, and John's Gospels do not offer a clear and definitive picture of who the Magdalene was within the original context of the life of Jesus of Nazareth. Rather, the essential scriptural materials are the textual foundation for both the elusive figure and the enigma which has become Mary Magdalene. The cultural historian Marina Warner has astutely referred to this textual confusion as "a muddle of Marys."[1] However it is exactly this literal puzzlement that results in theological tangles and most importantly in visual variety in the search for Mary Magdalene in the motifs of sinner, penitent, witness, contemplative, and muse.

The roots of the "muddle of Marys" are simple: first, the common use of the name Mary in the Christian Scriptures; second, the sparse descriptions distinguishing the many Marys one from the other; third, a series of similar actions by several of the Marys; fourth, a series of similar actions by several "unnamed women;" and fifth, the common human need for clarity combined with the faulty realities in the fusion of oral and narrative traditions. A story gets "better" or "longer" or more involved in each successive telling. Each retelling emphasizes different words or episodes. Human memory confuses common characters who become emblazoned in the imagination. As the human eye follows the path of light in a painting in order to see what it is about, the human mind requires a similar directional force in the reading, telling, and hearing of a story.

The "muddle of Marys" begins with the cultural commonality of the name Mary, which is the Greek form of the Hebrew *Miryam* signifying "rebellion" or *marah,* an adjectival root intending "bitter" or "grieved." The careful reader of the Christian Scriptures finds seven women named Mary who play a role in the life of Jesus of Nazareth and the establishment of the early Christian community. Without doubt the three most famous and important of these women are the Virgin Mary, the Mother of Jesus of Nazareth; Mary of Bethany, the sister of Lazarus and Martha; and Mary of Magdala, our particular heroine. Additionally, we find Mary "the mother of James" or "of James and Joses" or "of Joseph" and who is also referred to as "the other Mary" (Mark 15.40; Matthew 27.55–56; Mark 15.47; 16.1; Matthew 27.61; 28.1), and Mary wife of Cleophas (John 19.25).[2] Both play a role in the scriptural narratives related to the Entombment and Resurrection of Jesus Christ. Mary of Jerusalem (Acts 12.11–17) and Mary of Rome[3] (Romans 16.1–16) played significant enough roles in the formation of the early Christian community to garner mention in Pauline texts. Although there are distinctions between the Virgin Mary and the other Marys, the lines of demarcation are not as evident among the remaining women.

The woman identified specifically by the Gospel writers as Mary of Magdala is one of the earliest and most devout followers of Jesus of Nazareth (Luke 8.2-3) from whom he cast seven demons (Mark 16.9; Luke 8.2) and who stood at the foot of the cross (Matthew 27.56; Mark 15.40; John 19.25). She was one of "the holy women" who, seeking to anoint the crucified body at the tomb, found it empty and heard the announcement of the Resurrection (Matthew 28.1–8; Mark 16.1–8; Luke 24.1–10; John 20.1–9). She was the earliest witness of the Resurrected Christ (Matthew 28.1–10; Mark 16.9; John 20.1–18).

Perhaps it is as the first witness to the Resurrection that Mary Magdalene's fundamental fascination is found. This is the only episode in her story on which all the evangelists and later theologians will agree: that she was the first person not simply to see the empty tomb or hear the angelic announcement that "He is risen from the dead," but more significantly, *she* was *the* first person to *see* the Resurrected Christ. From this event, artists would create the visual image known as *Noli Me Tangere,* "Do Not Touch Me," which depicts the Magdalene reaching out to touch Christ just after his Resurrection. Artists trusted unconsciously in her act of faith in *seeing* as a scriptural defense for the visual modality and for Christian art. Her confidence in the evidence of her eyes triumphed over the human need to touch.

The woman that the Christian traditions, devotions, and art know as Mary Magdalene is more than this female follower healed from her demons and faithful to Jesus beyond his earthly sufferings and death. Though Scripture offers no evidence for the equation of casting out of demons with unchastity, it cannot be lost that Mary Magdalene later comes to be identified as a sinner who is guilty of promiscuity. Why? Perhaps, her geographic epithet, which has a dual meaning, played a role in her transformation into the Mary Magdalene we have come to know and love. Magdala is derived from the Greek form of Hebrew *migdol* meaning "tower" or more specifically "watch tower." As a description of her actions—standing like a "watch tower" at the foot of the cross and at the tomb—this Mary is signified correctly by her epithet's etymology. During Jesus' lifetime, Magdala, according to the historian Josephus, was a large, wealthy town on the western shore of the Sea of Galilee. Also known as Taricheae, Magdala was destroyed by the Romans as a result of its citizens' alleged moral depravity.[4] Such an identification could

have been interpreted over time to suggest that this Mary's "seven demons" were not some form of demonic possession, nervous disorder or illness but of promiscuity. This could account for the emerging confusion of the sinner with Mary of Magdala.

The singular rendering of *Mary Magdalene Healed by Christ* (fig. 2), which depicts malicious dark figures expelled from every orifice of her body, contributes to our perception of her "seven demons" as manifesting corporeal and soulful "possession." This is a rare visualization of the Christian rite of exorcism. The identification of Mary as "of Magdala," combined with the then-common understanding that physical and spiritual disease often went hand-in-hand, established her as a sinner. This leads to her later association, if not complete assimilation, with the nameless sinner (Luke 7.37) and the unnamed woman taken in adultery (John 8.1–11).

It is the nameless sinner who "loved much" and was forgiven, and the unnamed adulteress who have colored the Magdalene's persona in a manner distinct from the original scriptural texts. The nexus for the confusion, or conflation, of these two women is their shared experiences of sinfulness, repentance, and forgiveness, and their anonymity. Neither has a name or even an identifying epithet except for the category of sinner. Whether the gospel writers chose to keep silent about these women's identities for reasons of social or cultural etiquette or felt that their names were inconsequential to the stories' pedagogical purposes, is a subject of speculation. Their role as defining elements in the "composite Magdalene" figure as a moral reprobate is a historical reality.

The sins of which these two unnamed women, and thereby, the Magdalene are guilty are attributable to sexual incontinence—an obvious condition for the so-

named "woman taken in adultery" and an assumption for the nameless female sinner. It is probable that Luke's nameless sinner was innocent of lust or sexual misconduct. The concept of "love" in the Hellenistic world had a variety of meanings from *philia*, "brotherly love" or communal sharing, to *caritas*, "charity," to *agape*, "divine love." It would be toward to consider the possibility that what is taken as an admonition by Jesus, that this woman's sins are forgiven because she has "loved much," may be rather a description of her Christian nature and not her sexual proclivities.

Figure 2. MARY MAGDALENE HEALED BY CHRIST, Book of Hours, France, 1460–1470 The Pierpont Morgan Library, New York MS M. 54 f. 18

Nonetheless the proximity of her story in Luke's Gospel to the passage introducing Mary of Magdala exacerbates the eventual maze of the female anointers.

There are four anointing, or unction, episodes which have significant ramifications for the evolution of the Magdalene. Matthew and Mark provide us with almost identical reports of the anointing of Jesus of Nazareth by an unnamed woman in the home of Simon the Leper two days prior to the Passover.[5] In both accounts, she carries an alabaster box containing precious ointments that she pours over Jesus' head, an act which foreshadows the burial unction ceremony. Although this episode emphasizes the anointing theme, Judas' challenge to Jesus' authority combined with his decision to betray Jesus are thematic undercurrents. Curiously, this would be one of several scriptural, and later legendary, episodes in which the real or composite Magdalene's actions may be seen as correctives to those of a male disciple.[6]

The third story of anointment is distinctive in description and content as Luke relates that Jesus dines this time at the home of a Pharisee.[7] During the meal, an

dominte ihesu xpe
adoro te in cruce
pendentem ~ coro
nam spineam in

unnamed woman identified only as "a sinner" enters the room carrying an alabaster box of ointment. She washes Jesus' feet with her tears, dries them with her long-flowing hair, kisses them, and finally anoints them with the precious ointment. When the Pharisee questions this action and the physical proximity of an unnamed sinful woman to Jesus, he reprimands the Pharisee by reminding him that he has not complied with the normal acts of hospitality. Jesus continues that this "unknown woman" performed them with great humility and love, and he pronounces her many sins forgiven.

The fourth unction account is unique in its identification of the anointer. Unfortunately, she is called simply Mary.[8] Since this episode follows the Raising of Lazarus and appears to have happened in the house of Lazarus, this Mary is most likely Mary of Bethany, the sister of Lazarus and Martha. According to the Gospel of John, six days before the Passover, Jesus entered a home to partake of a meal when Mary anointed his feet and wiped them with her long-flowing hair. The expected dialogue

with Judas followed. Given the similarity in deeds, gestures, and effects—anointing with precious ointments, alabaster boxes, tears, long-flowing hair, repentant postures, and forgiveness for the female agent and betrayal by the male agent—the confusing conflation of the Marys and the anonymous women is understandable.

A further scriptural image, that of Mary of Bethany as the eager listener, is described in the Lucan account of Mary and Martha, the sisters of Lazarus.[9] Mary of Bethany garners Jesus' approval as the sister who shuns her domestic duties and listens carefully to his lesson. John implies that it is for her sorrow, copious tears, and faith in his message that Jesus raises her brother, Lazarus, from the dead. Following this miraculous narrative, John relates the story of the fourth anointment noting the anointer's prostrate posture and tears. The proximity of the events and the correspondence of characterizations commingle with the ubiquitous name of "Mary" and the otherwise unnamed women to create a homogeneous heroine, Mary Magdalene.

In Search of Mary Magdalene: Patristic Sources

HE SCRIPTURAL QUANDRY over the Magdalene's identity persisted throughout the formative texts of the church fathers and beyond the sixth-century proclamation of Pope Gregory the Great (c. 590–604).[10] Perhaps the earliest and most influential of them was Tertullian's (c. 160–220) determination that the otherwise unnamed woman taken in adultery and "Mary" were one and the same woman, for *both* anointed Jesus' feet and dried them with their hair (Luke 7.36–50; John 12.1–8).[11] Neither Tertullian's contemporaries nor later church fathers were in complete agreement with his analysis

that Mary Magdalene was the same as Mary of Bethany, the unnamed sinner, and the woman taken in adultery. For example, Ambrose of Milan (c. 340–397) was not clear in his discussion of the "muddle of Marys" as to either independent or composite identities of these women. Jerome (c. 340–420) was precise in his opinion that the unnamed adulteress and the anonymous sinful anointer were two different women. Although he saw "merit" in the composite Magdalene of Tertullian's text, Augustine (354–430) determined that the scriptural ambiguity left her identification open to question.

Mary Magdalene's identity became even more muddied when she was included in the list of invocations known as the *Litany of the Saints* (the first western written version dates from the seventh century).[12] Her name appeared at the beginning of the list of the holy virgins and widows.[13] There is no scriptural or legendary evidence that she may have been a widow who might have attained the state of "virginity" upon her spouse's death; in such an instance, virginity was synonymous with chastity and monogamy. Nor are there any theological or liturgical grounds to interpret the title "virgin" or the delineation of "all ye holy virgins and widows" as an honorific. Given the Christian moral climate contemporary to the issuing of the *Litany of the Saints*, the designation of the Magdalene as either a "holy widow" or a "holy virgin" could only have had a sexual connotation appropriate to the authoritative writings of Augustine and Jerome.[14] Thereby this text serves as liturgical testimony for the continuing confusion over her identity. Ambrose of Milan and Modestus of Jerusalem (d. 634) employed the title virgin when discussing Mary Magdalene in their texts.

Nonetheless, Gregory the Great concluded that a multiform Magdalene who was both sinful and penitent would prove more salutary to Christendom. He appropriated the common actions in the scriptural unction scenes and conflated the "seven demons" with immorality and sinfulness to proclaim that Mary Magdalene was all of these women in his *Homily 25.1.10*.[15] After all, he instructed his fellow Christians,

> The considerable time it took for the disciples to believe in the Lord's Resurrection may have been a weakness on their part; nevertheless, it served to our strength. In response to their doubts, they received numerous proofs of the Resurrection: when we become aware of them, we can say that the apostles'

doubts are the opportunity for us to affirm our faith. *Mary Magdalene, who believed immediately, is less useful to us than Thomas, who doubted for some time.*[16]

Following Gregory, the western Christian tradition acknowledged the multiform Magdalene as one woman who was sinner, penitent, anointer, and follower as well as witness to the Resurrection. However, the theological debate about her identity did not end with this series of papal pronouncements. Albertus Magnus (d. 1280), Bernard of Clairvaux (1080–1153), and Thomas Aquinas (c. 1225–74) among other theologians disputed her identity on scriptural, devotional or spiritual grounds. Perhaps the most controversial discussion of "the Magdalene question" was the declaration by Jacques Lefèvre d'Étaples (1455–1536). He argued that a careful reading of Scripture advocated that she was neither the unnamed adulteress or the sinful anointer but one of Jesus' original followers faithful unto his death and witness to his Resurrection.[17] While scripturally sound, Lefèvre d'Étaples' dictum met with immediate criticism not simply from theological colleagues but from the collective of Christian believers. In 1969 the Roman Catholic Church formally revised the canonical definition of Mary Magdalene in the *Calendarium Romanum*. She was returned to the early Christian description of faithful follower and first witness, and not the unnamed adulteress or sister of Lazarus and Martha.[18]

Eastern Orthodox Christianity followed Origen's (c. 185–254) definition of Mary Magdalene as faithful follower and first witness to the Resurrection. He distinguished between the unction episodes and the female anointers.[19] As a result, the three women, who are often confused or conflated with each other, are honored as distinct individuals with the separate feast days: the Converted Sinner, March 21st; Mary of Bethany, March 18th; and

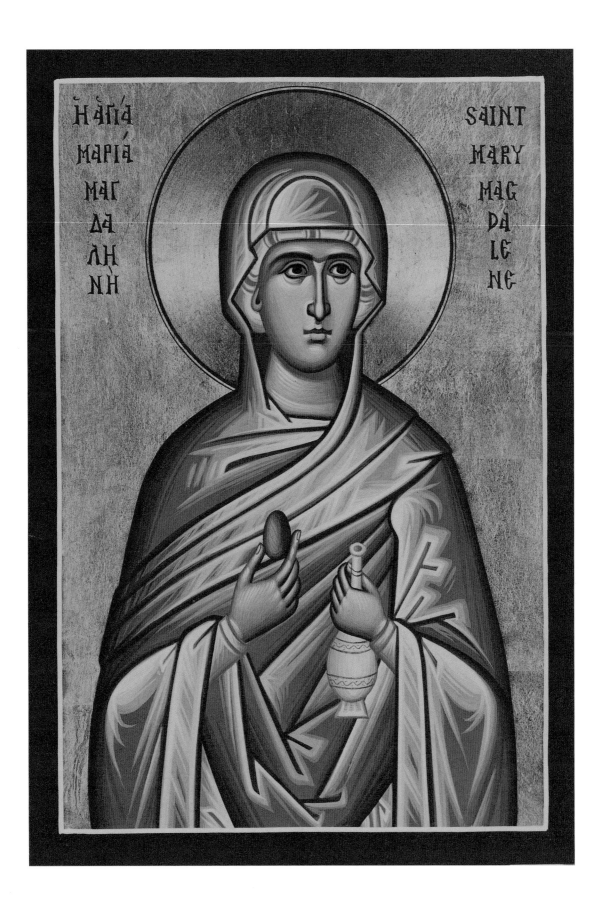

Mary Magdalene, July 22nd. The *Myrrophori,* or Myrrh-bearing Women, who attempted to anoint the body of the crucified Jesus are revered on the third Sunday of Easter.[20] Although named as one of the Myrrhbearing Women, Mary Magdalene is honored on July 22nd as "The Holy Myrrh-Bearer Equal-unto-the-Apostles."[21]

Adhering to Origen's formula, Gregory of Nyssa's (c. 335–94) praise, and a scrupulous reading of the Christian Scriptures, the Mary Magdalene revered in the Eastern Orthodox Christian traditions is the woman healed of demonic possession who becomes one of the pious women, along with Joanna and Susanna, serving Jesus, and sharing evangelic tasks with the Apostles (Luke 8.1–3). She followed Jesus faithfully, bore witness at the foot of the cross, endeavored to anoint the crucified body, and received the initial angelic pronouncement of the Resurrection. Mary Magdalene was the first to see the Risen Christ and to receive his proclamation of the Resurrection and Ascension. He sent her to announce this to the Apostles. Thereby she became the "apostle to the apostles."

Figure 3. MARY MAGDALENE HOLDING A RED EGG, 20th century, Icon Courtesy of Holy Transfiguration Monastery, Brookline, MA

The Matins for Holy Wednesday incorporate multiple references to Mary Magdalene as "the fallen woman," as myrrhbearer, and as witness. The most notable of these references is the *Hymn of Kassiani* which begins,

> The woman who had fallen into many sins recognizes Thy Godhead, O Lord. She takes upon herself the duty of myrrh-bearer and makes ready the myrrh of mourning, before Thy entombment.[22]

Beyond her scriptural role in the Easter liturgy, pious tradition relates that following the Pentecost, Mary Magdalene traveled to Rome where she presented the Emperor Tiberias with a red-colored egg. She proffered it as a symbol of the Resurrection and proclaimed, "*Christos Anesti!,*" "Christ is Risen!" This event is represented in the icon of Saint Mary Magdalene from Holy Transfiguration Monastery (fig. 3). Red-colored eggs became the symbol of *Pascha* and are exchanged by Eastern Orthodox Christians. The established prayer for the Paschal blessing of the eggs and cheese reads:

> Thus have we received from the holy fathers, who preserved this custom from the very time of the holy apostles, wherefore the holy equal-unto-the-apostles Mary Magdalene first showed believers the example of this joyful offering.[23]

Eastern Orthodox Christianity testifies in holy tradition to her many post-Pentecost activities—teaching and preaching—including her missions in Jerusalem and to Rome where she greeted the Apostle Paul and remained until his first court judgment.[24] Then she relocated to Ephesus where she worked with John on the first twenty chapters of his Gospel. After her death, her earthly remains where buried in the cave of the Seven Saints of Ephesus only to be translated to the Monastery of St. Lazarus in Constantinople in the ninth century. Her relics were transferred to the Basilica of St. John Lateran in Rome by crusaders from whence fragments were moved later to France, especially to Marseilles and Vézélay.

The discussion of the Magdalene's life "after" the scriptural narratives was of concern to believers in the western Christian tradition. Her popularity among believers is signified by the pious legends and traditions which complete her earthly biography. Various sources, including the Roman martyrology, detailed versions of her evangelical missions to France. French

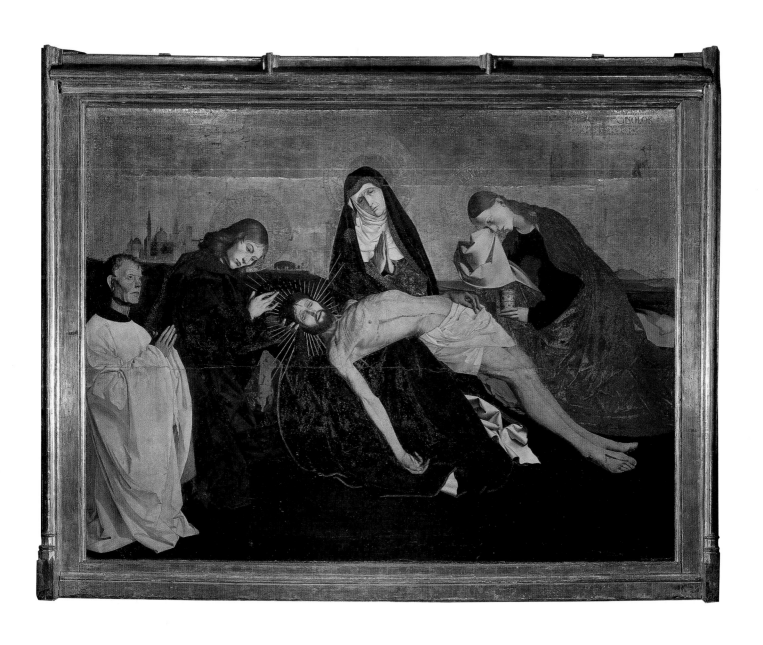

Figure 4. Enguerrand Quarton (French, 1410–c. 1464)
THE AVIGNON PIETÀ
Copyright Erich Lessing / Art Resource, NY
Louvre, Paris, France

legends related the episodes of her perilous sea journey from the Holy Land to the south of France, her ministry of teaching and healing, her years of penance in either the French woods or a cave, and the ministry of angels at her death. Sanctuaries and shrines for her relics are found in Les Saintes-Maries-de-la-Mer, Sainte Baume, Vézélay, and Aix-en-Provence, as well as the many medieval French cathedrals dedicated to *La Madeleine*.[25] Earlier legends, as well as Egyptian gnostic texts, account for her last days being spent with Thomas in India or the Risen Christ in the desert. After Pentecost, according to an Eastern Christian tradition, Mary Magdalene traveled to Ephesus with John and the Virgin Mary where they remained until their respective earthly demises.

Medieval legendary and devotional texts continued this varied tradition of Mary Magdalene's life. For example, Jacobus de Voragine (c. 1230–98) related her "pre-conversion" life as a wealthy proprietor in Magdala; her role as the bride at the Marriage at Cana; and her pilgrimage to Rome. A series of devotional *vitae* continue her metamorphoses by conflating her with Mary of Egypt (ninth-century); the "other" scriptural Marys (tenth-century); and the Desert Mothers (eleventh-century). The cult of and devotions to the Magdalene gave formal voice to her role in the hearts and minds of the Christian collective.[26]

In Search of Mary Magdalene: Symbols and Devotions

RADITIONALLY IN Christian art, saints were represented by identifiable attributes or symbols which delineated their "martyrdom" in the most fundamental sense of the term—witnessing their faith. For example, Catherine of Alexandria is distinguished from Catherine of Siena via individual attribute: the spiked wheel and the cross surmounted by a lily or a heart respectively. The vitality of such symbolism confirmed the pedagogical role of Christian art. Controversies and debates about her identity aside, Mary Magdalene was recognizable by her fundamental attributes: an ointment jar, long-flowing hair, tears, and her position as observed in *The Avignon Pietà* (fig. 4). These visual connectors reference the Magdalene as the woman who anointed Jesus of Nazareth—either his feet, head, or crucified body. She is the indispensable conduit between the Christian ritualistic action of healing and protection, and human frailty.

The Magdalene's renowned jar is itself a symbol of metamorphosis. It transmogrifies into a diversity of shapes including alabaster containers, elegant perfume bottles, clear glass carafes, and golden liturgical vessels. As the protector of the precious and consecrated anointing oils, her jar signifies the unction which cleanses, preserves, and seals the anointed from evil, disease, and sin.[27] When its classical mythological referents are commingled with its role in the scriptural anointment episodes, the jar connotes metanoia.[28] When depicted as a beautiful perfume bottle, the Magdalene's jar signifies both her former life of pleasure and a link to her Hebraic foretypes, Susannah and Bathsheba, whose luxurious flagons held fragrant bath oils. Just as the jar portends metanoia, unction, and metamorphosis, it serves as a reminder that at the very bottom of Pandora's box lay Hope.[29]

Mary Magdalene's long-flowing hair references her roles as anointer and repentant adulteress. Hair in its

condition, color, and style emblematized physical, spiritual, and societal characteristics, especially in classical and early Christian culture. Hair typified energy and fertility; a full head of hair embodied *joie de vivre*, *élan vital*, and resolution to succeed. As the head signified the most spiritual part of the human body, being the closest to the heavens, hair on the head connoted spiritual energy. Healthy, abundant hair such as the Magdalene's exemplified her spiritual development following upon her healing or conversion.

Hairstyles had significance in the classical world.[30] Typically, young unmarried women allowed their abundant tresses to flow freely down their necks and over their shoulders in a style synonymous to that of the female personifications of sacred love. Proper married women covered their heads in public as both a sign of their social station and of preservation of their "energy" for their husbands. Courtesans braided their hair, piling it high atop their heads. They decorated these styles with bejeweled or flower ornaments alluding to the female personifications of profane love. If she embodied the "sinful" side of her complex persona, the Magdalene's hair is elegantly coiffed and decorated with jewels, flowers, and ribbons. Her long-flowing hair signifies the invocation to her as a "holy virgin" in the texts of the early church fathers and the *Litany of the Saints*.

Given its relation to the planet Venus, copper- or red-colored hair implied a venereal character and thereby was associated with sexuality. As the residents in the classical Mediterranean were predisposed to olive skin with dark hair and eyes, any person with fairer skin and hair tones was noticed. During the Middle Ages and Renaissance, Mary Magdalene was depicted with beautifully braided and arranged red hair to connote her lascivious nature prior to her healing or conversion.

Tears, especially the large pearl-shaped ones dripping slowly from the eyes, signified that Mary Magdalene had been granted the *donum lacrimorum*, "the gift of tears," as espoused by the church fathers and the medieval mystics. Shed in repentance, the Magdalene's tears symbolized her self-knowledge and recognition of her finitude and guilt. Her tears were the external expression of the spiritual action of the purification of the soul. Therefore, silent penitential tears—not the physical contortions of sobbing or hysteria—became a visual attribute of the Magdalene.

Other well-received depictions include the Magdalene engaged in contemplative penance. Her bodily posture and the attributes of skull, scourge, or crucifix, signify that she is lost in her thoughts about the transitory nature of human existence. She may be pictured deep in contemplation gazing into a mirror—not in reversion to her former narcissism but rather in spiritual introspection. She was rendered as a disheveled, haggard, and wan figure with a prayerful gesture denoting either penance or preparation for death.

The patroness of penitents and flagellants, vintners and coiffeurs, weavers and couturiers, perfumers and jewelers, Mary Magdalene has played multiple roles in Christian spirituality and devotions. During the Middle Ages and Renaissance, she was the spiritual advocate of confraternities dedicated to the penitential discipline of self-flagellation, and of cloistered nuns devoted to the contemplative life of silent prayer. She is credited with many miracles including spectacular cures, the liberation of prisoners, the raising of the dead, fertility, and successful childbirths.

In Search of Mary Magdalene through Christian Art

ISTORICALLY, CHRISTIAN art has not been overtly concerned with the scriptural or theological debates as to the identity of Mary Magdalene. Its focus, especially in the early Christian period, was on a saint's role as witness to Jesus as the Christ. For early Christians, then, the Magdalene's "dignity lies in her proximity to the mystery of salvation,"[31] not in her personal story.

Early Christian art was concerned with the visualization of faith either as a form of devotion or of pedagogy. Any search for individual representations of Mary Magdalene would prove fruitless. She is found in the context of those miracles and scriptural episodes in which she played a part like the Casting Out of the Seven Demons or the Resurrection. She can be identified in visual narratives of scriptural stories which featured the anonymous women like the Anointing at Bethany and the Woman Taken in Adultery. Mary Magdalene is portrayed clearly in scenes of the Resurrection, including the Apparition of the Risen Christ presaging the *Noli Me Tangere* which appears first in the late Middle Ages and early Renaissance.

During the transition from early Christian to medieval art, the composite image of the Magdalene was defined by her conflation with the converted sinner, repentant adulteress, and Mary of Bethany. She begins her transition from an element of the traditional saintly female figures of early Romanesque art to become an unique and independent topic in the archways, portals, and walls of Gothic cathedrals. The Middle Ages can be characterized as an era of faith and an awareness of the power of sin. The Magdalene was venerated as a penitential saint. The periods of the "great plague" (c. 1348–99)

highlighted the recognition of human suffering, misery, and the fragility of human life. As the eminent female sinner who experienced the healing love and forgiveness of Jesus of Nazareth, she symbolized spiritual encouragement for her fellow human sinners— *Ne Desperetis Vos Qui Peccare Soletis, Exemploque Meo Vos Reparate*, "Do not despair you who are accustomed to sin but do penance following my example,"—is written on her scroll (see fig. 1).[32]

Liturgical dramas and Passion plays flourished during the Middle Ages. Mary Magdalene was a featured character in the traveling plays, especially in the Lamentation and Resurrection episodes. With the emergence of Franciscan spirituality (thirteenth century), the saintly and matronly Magdalene was "humanized" on the stage and in Christian art. Her hair was no longer covered by a mantle or veil. Similarly, the illustrations of her found in the mysteries of salvation, which had been located on the façades and portals, were re-located inside the cathedrals on the windows, walls, carpets, and altar tableaux. This transition allowed the faithful a new proximity to the Magdalene inside the church.

Beginning in medieval art and throughout the Renaissance, her position under the cross and within the scriptural sequences related to the fusion of the converted sinner and adulteress. Artistically and spiritually, this conflation had practical and profound motives: devotional empathy in the viewer for the expiatory sacrifice of Jesus of Nazareth. For as the Magdalene empathized with him, so too could we, through the vividness and immediacy of her eye-witness vision. The hapticity of the distraught and "fallen" woman at the foot of the cross provided a visual association for

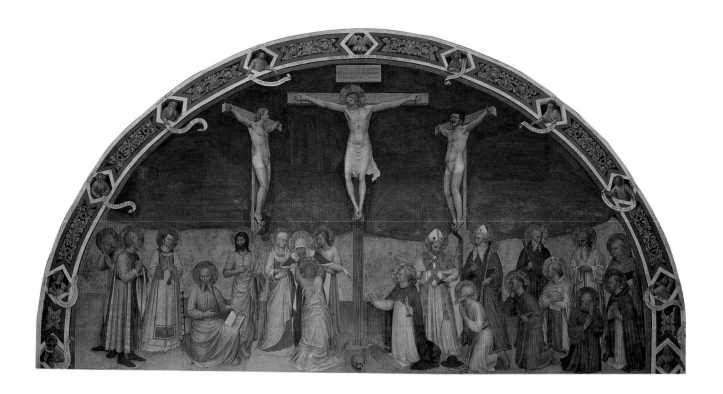

Figure 5. Fra Angelico (Italian, 1387–1455)
CRUCIFIXION (above and [detail] left)
Copyright Scala/Art Resource, NY
Museo di San Marco, Florence, Italy

Figure 6. Master of Virgo Inter Virgines
(active c. 1470–1500)
CRUCIFIXION (right)
Copyright Scala/Art Resource, NY
Uffizi, Florence, Italy

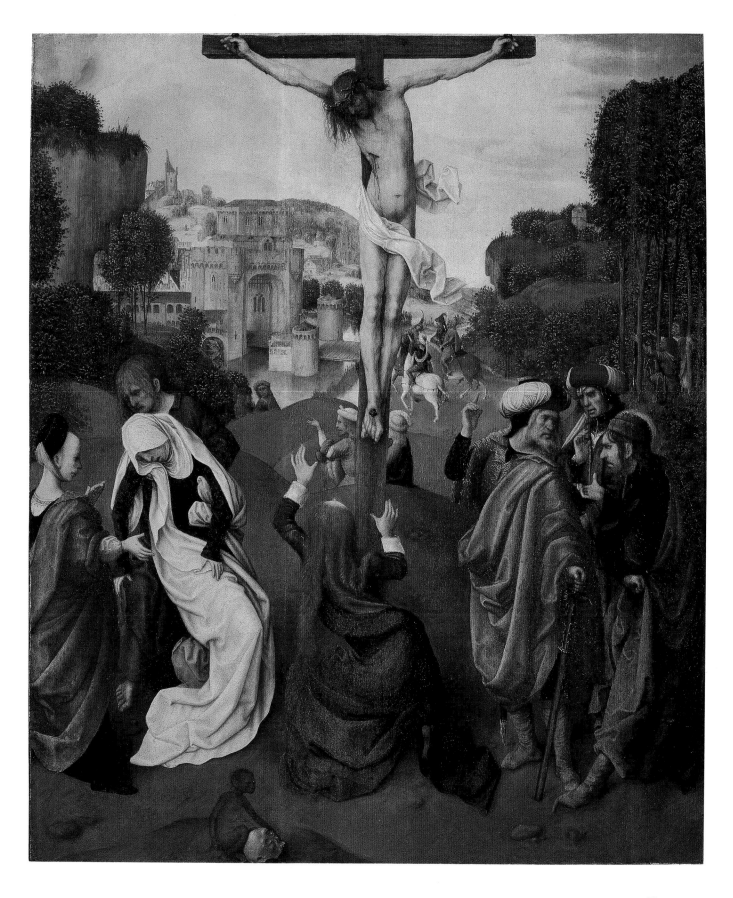

the Christian believer, whether through the meditative aura of Fra Angelico (fig. 5) or the contorted drama of the Master of the Virgo inter Virgines (fig. 6). These images of the Magdalene fuse two scriptural motifs: the woman kneeling at Jesus' feet, the same feet she earlier anointed and wiped with her own hair in anticipation of his death and burial; and the etymology of her epithet, for she stands as the sentry of the watchtower as his body hangs on the cross.

Fra Angelico expands the boundaries of the Magdalene as common intercessory figure. She becomes a physical channel between the mother, who has collapsed from sorrowful empathy, and the son who has suffered unto exhaustion. This artistic vision of Mary Magdalene is that of the mediator between both the Virgin Mary as Mother Church and her son as the sacrament; between the Christian collective and the sacraments. In an extraordinary presentation of the Virgin Mary's *compassio*, Fra Angelico transfers the Magdalene from her normative position at the foot of the cross to one on stage left. She becomes the physical and spiritual support of the mother whose bodily posture parallels that of her crucified son.

The Master of the Virgo inter Virgines exemplifies the art historian Millard Meiss' statement that the "desperate Magdalen [sic] makes an appearance at the foot of the cross."[33] The exaggerated and contorted posture of her body simultaneously evokes the depth of her otherwise silent grief and her role as mediator between mother and son, church and sacrament. Her glorious long-flowing red hair "crowns" the plantlike position of her green clad body in a visual metaphor of the rebirth of faith that will follow upon this grievous event. Created within the spiritual milieu of the *imitatio Christi*, this is a devotional picture of the highest order. The immediacy of the Magdalene's eyewitness account evokes the viewer's emotive response.

The theme of the *Noli Me Tangere* representing the Appearance of the Risen Christ to Mary Magdalene, originates in late medieval and early Renaissance art, and promotes her increasing significance as depicted in Martin Schongauer's altar panel painting (fig. 7). She has become the feminine symbol of penitence, humility, and love as communicated through her kneeling posture at the Risen Christ's feet and her eloquent gestures in relation to his right hand. The dramatic intention of his dictum is expressed in the poignant but empty space between their hands.

The spirituality preached through the Mendicant orders, particularly through the writings of Bonaventure (1221–74) and Jacobus de Voragine, in southern Europe, and the devotionalism of the Rhineland mystics and lay movements such as the *Devotio Moderna* in the north, cemented this theological symbolism

Figure 7. Martin Schongauer (German, 1435–1491), NOLI ME TANGERE c. 1470–1480, Oil on wood Musée Unterlinden, Colmar, France

for the Magdalene. Her popularity as a devotional and spiritual figure waxes with the need of the Christian believer to understand and experience the otherwise abstract concept of forgiveness. She was the great sinner who repented, received forgiveness, became the devoted disciple, and was the first witness of the Resurrection. As the Liturgical drama emphasized the Magdalene's redemptive past, artists like Schongauer gave visual expression to her position through her extraordinary hand gestures in relation to those of the Risen Christ.

She "was one of the favorite subjects of Renaissance paintings, and pictures of her abound. Some are devo-

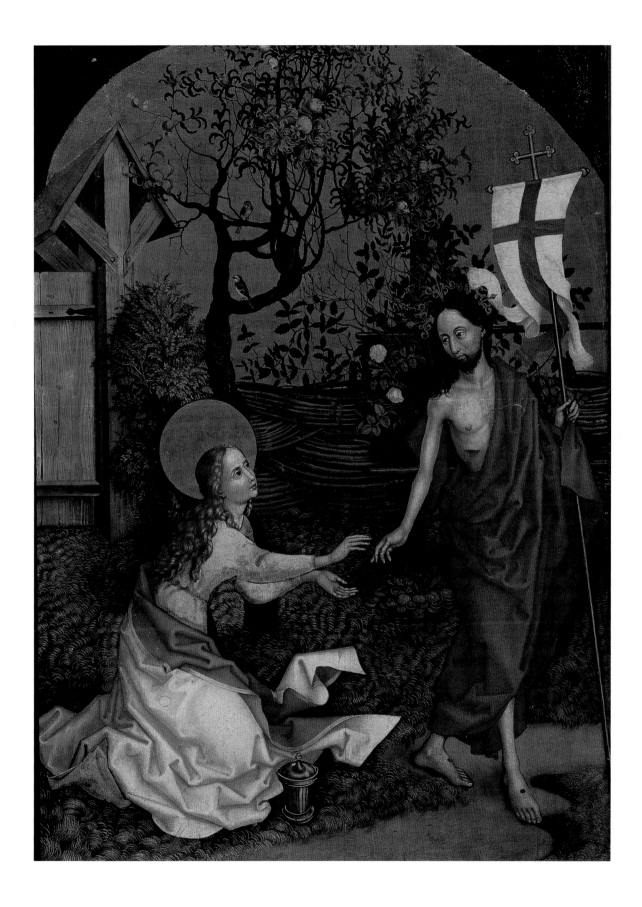

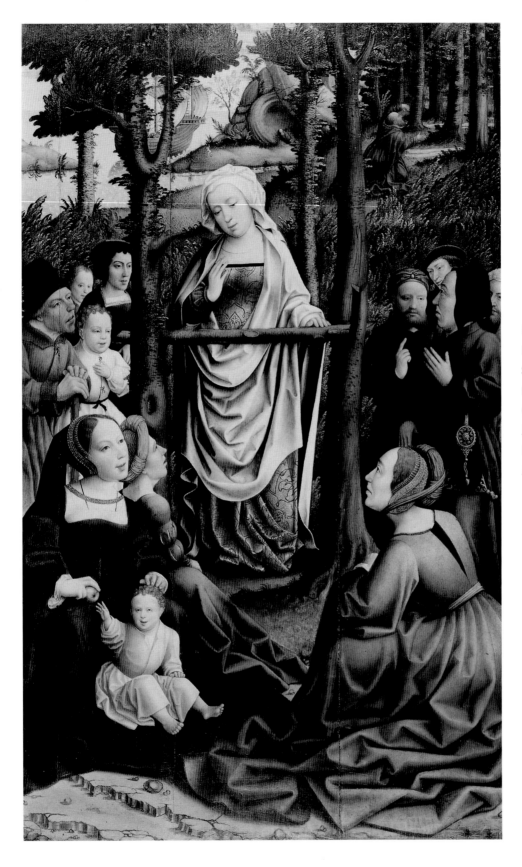

Figure 8. Master of the
Magdalene Legend
SAINT MARY MAGDALENE
PREACHING, c. 1500–1520
Oil on panel
John G. Johnson Collection
Philadelphia Museum of Art
J No. 402

tional, but many show scenes from the Gospels and her legendary life."[34] Renaissance representations of Mary Magdalene evidence both her prominence in Christian spirituality and her popularity among believers. She has become a clear and distinct individual—no longer an "element" in the narrative. The early sixteenth-century altarpiece by the Master of the Magdalene Legend consists of six individual panels dedicated to scriptural and legendary episodes including the rare *Mary Magdalene Preaching* (fig. 8) and even rarer *Magdalene Hunting*. A careful *looking* at *Mary Magdalene Preaching* suggests that this representation of her post-Pentecost mission to France depicts her standing within a forest with the cave for her meditative penance in the background. Anchored in the far distant background is the ship on which she and her companions sailed to France. Her audience, composed of men and women, includes several mothers with young children seated in front of the green-clad Magdalene. They emphasize her special role as patroness of infertile women and of women in childbirth. The Magdalene's story is never linear; her identity, symbolism, and imagery are never simple. Her complexity is a critical element in her appeal to believers.

Devotional, legendary, and theological books were crucial resources for these medieval and Renaissance metamorphoses of Mary Magdalene. Pseudo-Bonaventura included important references to her in his *Meditations on the Life of Christ* which was an important source for Christian art. Medieval commentators affirmed that the bridal couple at Cana were to have been Mary Magdalene and John the Evangelist, an association which originated in Jerome. Following Origen, the medieval champion of the "scripturally real" Mary of Magdala, Bernard of Clairvaux linked the bride of the *Song of Songs* with the anointer of Jesus of Nazareth and thereby signified the fusion of *eros* with *agape*, earthly love with divine love.[35] The Magdalene was transformed from

saintly matron to a heroine of Christian virtues as communicated in images of her as reader. Although the motif of a holy woman reading was not unknown in Christian art, Rogier van der Weyden painted the first known image of *The Magdalene Reading* (fig. 9) in 1436. The collective acceptance of van der Weyden's presentation of the contemplative reader was affirmed in its "mass production" in fifteenth- and sixteenth-century northern European art.

Early Modern Europe—the time of the Reformation and the Counter-Reformation[36]—was a period of profound spirituality and devotionalism. The Magdalene found a renewed and expanded audience among the Christian collective, especially within Roman Catholicism. Leading Italian and Spanish Baroque artists exalted her as a defender of the faith. With Peter, she became the guardian of the sacrament of penance. Her tears shed in expiation of her "sins" paralleled his shed in contrition for his denial. She became a symbolic crusader for the Roman Catholic tradition, which promised salvation through the sacramental mysteries of the church.

Artists found a new kinship with theologians and liturgists as a Roman Catholic iconography developed to elucidate that tradition and to encourage the faithful. Representations of the Penitent Magdalene, her Last Communion, and the Contemplative Magdalene flourished. Although Baroque artists accentuated her sensual nature and voluptuousness through color, dramatic lighting, flowing drapery, and provocative poses, the spiritual and devotional motivation effected by the Magdalene remained strong. Southern Baroque artists portrayed her as a beautiful young woman dressed in revealing attire, her hair cascading over her shoulders, as she tearfully contemplates her fate. Her nakedness personified not wantonness, but rather her "new life"

in the spiritual purity born of repentance and forgiveness. The Magdalene as subject of art, devotions, and spirituality was esteemed at this time of sacramental intensity.

Michelangelo Merisi da Caravaggio, the controversial Baroque master, painted several versions of Mary Magdalene including his singular version of the *Penitent Magdalene* (fig. 10).[37] He painted her long, red hair flowing down her back and her left shoulder as she crouched in a fetal position, visualizing the depth of her remorse and guilt. Clad in an elegant, green garment and a white blouse with billowing sleeves, she lowers her head to her left and clasps her womb with her hands. Her body language conveys a tragic figure internalizing her emotions. She became a formal vision of concentric circles composed of her bodily posture, her gestures, her billowing sleeves, her encircling mantle, and her capacious skirt which overflows her body and her chair.

On the floor to her right lay her discarded jewels, signifying the old life she has cast off. A clear glass jar, ostensibly containing perfume or aromatic oils, is strategically placed between her pearls and herself. Large pearl-shaped tears drip slowly from her right eye down her cheek. She is the visual epitome of metanoia. Her repentance will result in a new life—a metamorphosis if you will—as the Magdalene moves from sinner to penitent to saint.

The eighteenth-century rise of modern science, politics, and economics brought about the secularization of western culture. The repercussions for the arts, especially for Christian art, were profound. Although the Magdalene continued to effect religious devotions, she initiated a "new life" as a secular symbol for the reformed prostitute in art, literature, and common parlance.[38] The arts and spirituality of the nineteenth century were permeated with a "Magdalene revival" from her secularized images as Camille, Thaïs, and Violetta to the spiritualized visions in nineteenth-century Roman Catholic revival of interest in

the medieval. The Romantics were attracted to the "heroine" of the Christian story.[39] The Symbolists were fascinated with her as a *femme fatale*.[40] Transformed along with Cleopatra, Judith, and Salome, the Magdalene was characterized by her abundant flowing hair, androgynous body, and blatant sexuality.

Alternatively, a more "delicate" figuration remains in the crypto-religious art of the Pre-Raphaelite Brotherhood and the Nazarenes, and extends into the works of Academy painters such as Jean Béraud's, *Mary Magdalene at the House of the Pharisee* (fig. 11). This painting of the anointing in the home of the Pharisee portrays Mary Magdalene resplendent in contemporary evening clothes and elegantly coiffed copper-colored hair. She is dramatically prostrate at Jesus' feet. The polished interior scene includes a refined dining table set with Haviland Limoges and surrounded by a melodramatic assemblage of male diners and a stately serving maid. More of an exquisite period painting than a spiritual vision, Béraud's canvas was renowned for the then-identifiable portrait of the author of the controversial *Story of Jesus*, Joseph Ernest Rénan (1823–92), on the face of Jesus of Nazareth.[41]

The Magdalene entered the twentieth century with her now familiar ambiguity and complexity. She has waxed and waned as spiritual and as secular image in the multi-media world of the "modern" arts. Haunting but puzzling images of the contemplative peni-

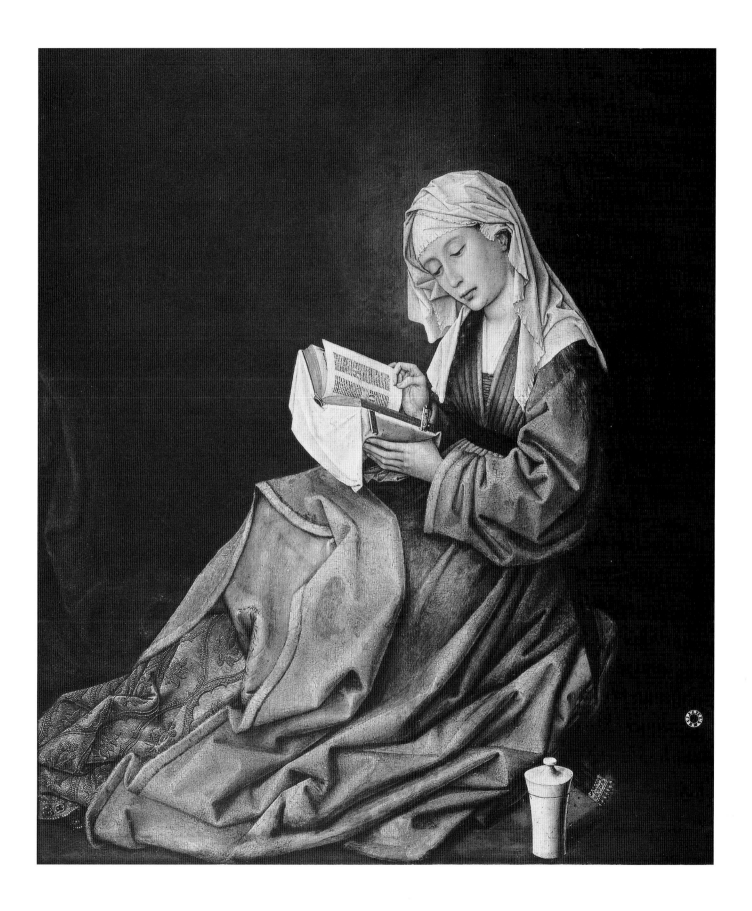

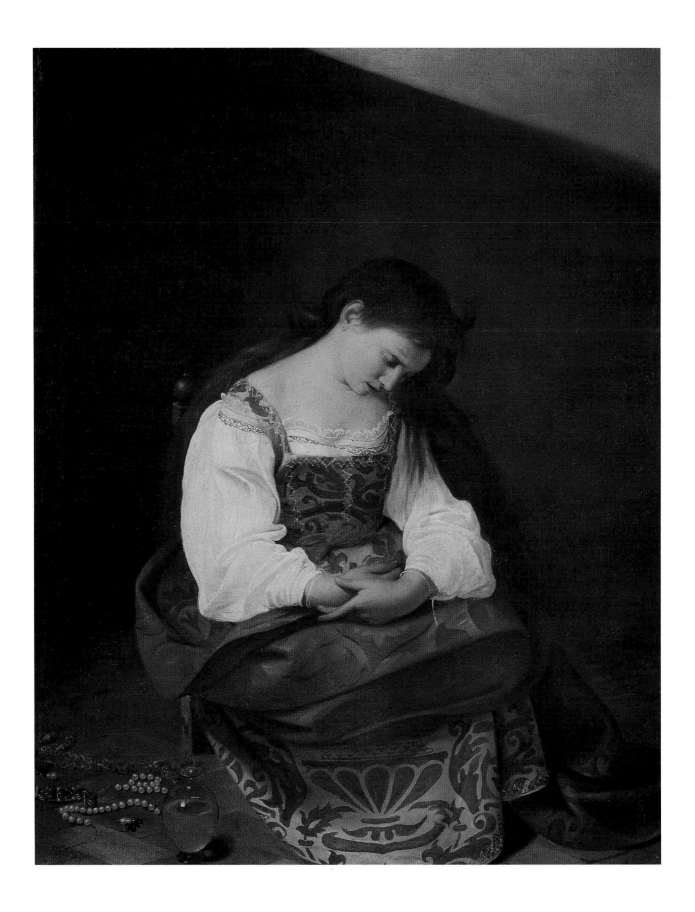

Figure 10. Michelangelo Merisi da Caravaggio
(Italian, 1573–1610)
PENITENT MAGDALENE
Copyright Scala/Art Resource, NY
Galleria Doria Pamphili, Rome, Italy

Figure 11. Jean Béraud
(French, 1849–1936)
MARY MAGDALEN AT THE HOUSE OF
THE PHARISEE, 1891
Copyright Erich Lessing/Art Resource,
NY, Musée d'Orsay, Paris, France

tent have vacillated with depictions of the immoral seductress and the terrified suffering sinner in the competing styles of the secular century from abstraction to cubism through expressionism into post-modernism. She has appeared in cinematic biblical epics such as the original *The King of Kings* to *The Last Temptation of Christ*. The Magdalene has been the inspiration for contemporary music about lost loves, betrayed wives, jilting vixens, and faithful lovers. She has been fictionalized as heroine, victim, and seductress in novels, magazines, and theatrical productions. Perhaps most significantly, she has been the topic of television documentaries.

Even in the secular century, the Magdalene can not be ignored or diminished. She may wane as a devotional or spiritual figure but she never disappears from the human consciousness. Perhaps no twentieth-century artist appreciated her enduring power more than Pablo Picasso. For him, she was the metaphysical embodiment of human frailty tempered by indubitable faith. His numerous renderings of the *Weeping Woman* (fig. 12) are recognizable descendants of the Christian motif of the Magdalene as holy weeper.[42] Picasso's lamenting woman retrieves that crucial aspect of the Magdalene as the universal female

Figure 12. Pablo Ruiz Picasso (Spanish, 1881–1973) WEEPING WOMAN, 1937 Drawing, Courtesy of the Fogg Art Museum, Harvard University Art Museums, Francis H. Burr Memorial Fund

metaphor for public as well as personal agony tempered by faith. Ambiguity and complexity, enigma and solution, injury and balm, sinner and saint—Mary Magdalene expresses and embodies the fullness of human experience. She is the living mirror of the virtue of mercy.

In Search of Mary Magdalene: Preliminary Conclusions

"BUT WHAT," the art historian Erika Langmuir writes, "of the imagery of that most problematic female saint, Mary Magdalene?"[43] Her image has vacillated between being the first Christian witness to salvation and an excuse for depictions of the female nude. Artists took their visual clues in her transformations from witness to agent as she vanquished a dubious, if not scandalous, past to emerge as the model female penitential saint. Throughout this journey, the Magdalene has exhibited a flexibility in image and definition unknown by other Christian saints. Her physicality transcends human limitations and flourishes in the assemblage of the sacred and the secular personae who bear her name.

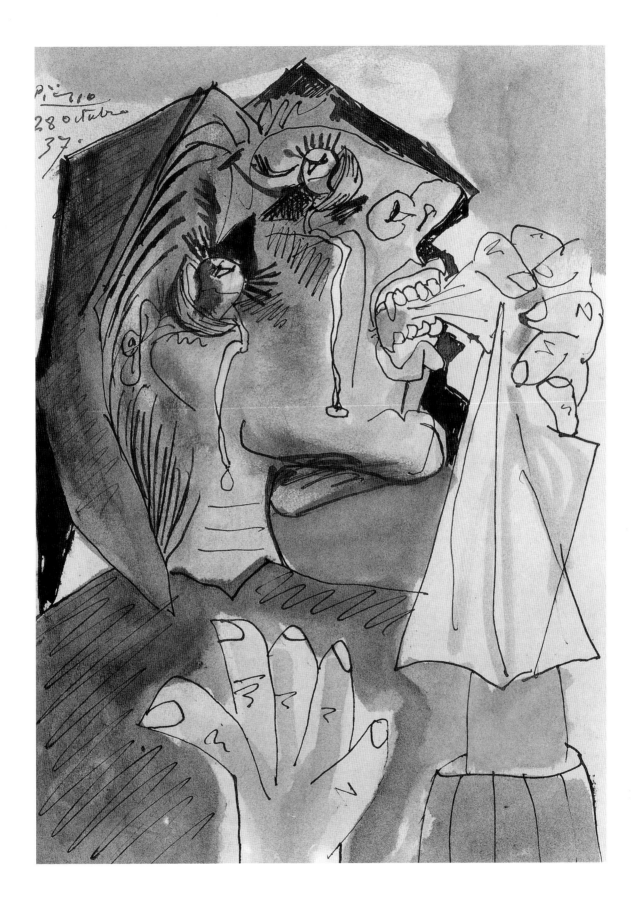

[1] Marina Warner, *Alone of All Her Sex: The Myth and the Cult of the Virgin Mary* (New York: Alfred A. Knopf, 1976); 344–45.

[2] In my own study of Christian iconography, I prefer to use the Douay-Rheims Bible for both the richness of its language and its historical appropriateness to the times in which many of the works of Christian art were created. Artists were familiar with the version(s) of the Bible available during their own lifetimes, and their work and symbolism may be more accessible or understandable with a reading of that rendering of the scriptural texts. Throughout this essay and the iconographic entries, my scriptural references are from *The Holy Bible Douay Rheims Version* translated by Bishop Richard Challoner, 1749–52 (Rockford: Tan Books, 1971 [1889 edition]).

[3] The "confusion" with Mary Magdalene will become apparent in the context of the discussion of the Eastern Orthodox Christian devotional and iconic traditions.

[4] The "unsavory" reputation of Magdala is described in the Talmud, Josephus (*Jewish Wars* 3:10), and Pliny. For a discussion of this tradition, especially as interpreted in the Talmudic sources, see Helen M. Garth, *Saint Mary Magdalene in Medieval Literature* (Baltimore: Johns Hopkins University Press, 1950), especially 77.

[5] See Matthew 26.6–13 and Mark 14.3–9 respectively. Ironically, Bethany is also home to Lazarus and his two sisters, Mary and Martha. This geographic coincidence probably heightens the eventual confusion between Mary of Magdala and Mary of Bethany.

[6] See the discussion of the correspondence between the Magdalene's role in what becomes known as the *Noli Me Tangere* to that of the male disciple in the *Doubting Thomas*.

[7] Luke 7.36–50. Luke's narration of the Feast in the House of the Pharisee follows his account of the raising of the son of the widow of Naim. This establishes the pattern of a foretype of the Resurrection of Jesus Christ followed by an anointment episode.

[8] See John 12.1–8. In the earlier Raising of Lazarus episode, John identifies the sister as "that Mary which anointed...." (John 11.2).

[9] See Luke 10.38–42.

[10] For the patristic discussions of the Magdalene's identity, see Victor Saxer, *La Culte du Marie Madeleine en Occident, des origines à le fin du moyen âge* (Paris: Librarie Claveuil, 1959), 1.1–31; 2.327–50.

[11] See Tertullian, *De pudicitia*, 11.2.

[12] The list of petitions in the *Litany of the Saints* is contemporary to the lives of the martyrs. The first Western text of the invocations was written in Greek in Rome and dates from the seventh century. Earlier texts existed in the Eastern Mediterranean.

[13] My original source for this information was Peter Ketter, *The Magdalene Question* (Milwaukee: The Bruce Publishing Company, 1935), 83. See also *Brevarium Romanium* (1952): "*Sancta María Magdaléna, ora...Omnes sanctae Vírgines et Víduae...*" (251); the *Roman Breviary* (1950): "St. Mary Magdalen,...All ye holy Virgins and Widows..." (209). The *Litany of All Saints* of *The Roman Calendar: Text and Commentary* (1976) reflects the 1969 canonical changes so that Saint Mary Magdalene is the last-named entry for the "Prophets and Fathers of our Faith" (129–30). I am grateful to Joseph N. Tylenda, S.J., for our discussion on this liturgical conundrum.

[14]The early Christian categories of "virgin" and "widow"as shaped by the Church Fathers are discussed by several scholars including Ute E. Eisen, Katharine Ludwig Jansen, and Victor Saxer. In classical Mediterranean culture a virgin was an "independent woman," that is, one who stood without the financial or societal support of a man be he husband, brother or father. This "independence" was not related to any form of sexual knowledge or experience. For example, the epithet "virgin goddess" was employed for Hera, Aphrodite, and Athena; and in point of fact, Hera annually underwent a "ritual bath" to restore her "virgin powers." See my entry, "Virgin/Virginity" in the *Encyclopedia of Comparative Iconography* (Chicago: Fitzroy Dearborn, 1998), II: 899–906.

[15]Gregory's homiletic texts were dependent upon his reading of Tertullian's *De pudicitia* 11.2.

[16]Gregory the Great, *Homily 29*. The emphasis is mine.

[17]For a brief discussion of Lefèvre d'Étaples' texts and their implications for the iconography of Mary Magdalene, see the entry "*Muse*" in this catalogue.

[18]The entry for 22 July under *Variationes in Calendarium Romanum Inductae* reads as follows:

> *Nil mutatur in titulo memoriae huius diei, sed agitur tantummodo de S. Maria Magdalena cui Christus post suam resurrectionem apparuit, non vero de sorore S. Marthae neque de peccatrice cui Dominus remisit peccata (Lc 7, 36–50).*

> *Calendarium Romanum* (Vatican: Typis Polyglottis Vaticanis, 1969), 131.

[19]See *In Matthaeum*, series 77.

[20]This feast is known as the Sunday of the Myrrhbearing Women. As Lent and Easter are moveable feasts in Eastern Orthodox Christianity, the date for this feast is set as the Third Sunday of Easter. The iconography of the Myrrhbearing Women, or *Myrrophori*, is the "most ancient depiction of Pascha" and first appeared on an early third-century fresco at Dura-Europos. See Michel Quenot, *The Resurrection and the Icon* (Crestwood: St. Valdimir's Seminary Press, 1997), 93.

[21]See the *Synaxarion of the Eastern Orthodox Church*. The Synaxarion is a listing of the Feast Days and Saints of the Eastern Orthodox Church. Given the autocephalous nature of Eastern Orthodox Christianity, the Synaxarion will have regional and national differences but the major feasts and saints will remain universal.

[22]The *Hymn of Kassiani* was written by the ninth-century Abbess Kassia. The translation quoted here is from the *Greek Orthodox Holy Week and Easter Services* compiled by George L. Papadeas (Daytona Beach: Patmos Press, 1979), 104. For an alternate translation, see *The Services for Holy Week and Easter* trans. Leonidas Contos (Northridge: Narthex Press, 1999), 138. The Matins for Holy Wednesday are often sung in anticipation on Holy Tuesday evening. However it is important to note that the Holy Wednesday evening service includes Holy Unction for all believers.

[23]From a hand-written *ustav* in the library of the Monastery of Saint Athanasius near Thessalonika.

[24]According to Eastern Orthodox Christian tradition, the Magdalene's mission to Rome is described in the Epistle to the Romans 16.6.

[25]Perhaps the most famous of the cathedrals dedicated to her in France is the *Église de la Madeleine* in Paris. This is "the church" of such legendary women as Gabrielle Chanel and Marlena Dietrich as well as other couturiers, models, seamstresses, actresses, songstresses, and dancers.

[26]For brief discussions of the Reformers' view of the Magdalene and her role in the Protestant traditions, see the iconographic entries in this catalogue.

[27]Early Christians recognized the linguistic relationship between salvation and redemption through the anointing oils as the Hebrew *messiah* became the Greek *christos* which translate as "the anointed one."

[28]The symbolic links between the Magdalene's jar and Pandora's box have been carefully delineated by several commentators including Marjorie Malvern and Susan Haskins. However the more interesting connection may be that between the iconography of the repentant Magdalene to the Cretan tradition which relates that the bodies of dead children were arranged in the fetal position and placed within amphorae as the source of physical and intellectual life, i.e., the mother's womb. For the Cretan tradition, see Jean Chevalier and Alain Gheerbrandt, eds., *A Dictionary of Symbols* (Oxford: Blackwell Reference, 1994 [1982]), 552.

[29]Pandora's curiosity overwhelmed her restraint so that she opened the "forbidden" box and released evil, disease, and suffering into the world. However she shut the lid quickly enough to retain Hope.

[30]Diane Apostolos-Cappadona, *Dictionary of Christian Art* (New York: Continuum, 1994), 153–54.

[31]Johannes H. Emmminghaus, *Mary Magdalene: The Saints in Legend and Art* (West Germany: Aurel Bongers Publications, 1964), 5:15.

[32]This translation from the original Latin inscription is mine.

[33]Millard Meiss, *Painting in Florence and Siena After the Black Death* (New York: Harper Torchbooks, 1951), 127.

[34]George Ferguson, *Signs and Symbols in Christian Art* (New York: Oxford University Press, 1980 [1966]), 135.

[35]See Origen, *Commentary on the Canticle of Canticles*; Bernard of Clairvaux, *Sermons on the Song of Songs*, especially Sermon No. 57. Another "link" in this tradition is the text of the Matins for Holy Wednesday in Eastern Orthodox Christianity and Kassia's *Hymn of the "Fallen Woman."*

[36]Leading church historians, most notably John O'Malley, have replaced "Counter-Reformation" with "Early Modern Europe" to signify the larger cultural, political, and social permutations from 1517 into the eighteenth century in Europe. For example, see *Early Modern Catholicism: Essays in Honour of John W. O'Malley, S.J.* ed. Kathleen M. Comerford and Hilmar M. Pabel (Toronto: University of Toronto Press, 2001).

[37]See also his figuration of the Magdalene in his *Entombment* and *Death of the Virgin*. His *The Magdalene in Ecstasy* is a unique vision of the merging of *eros* with *agape* as it was understood in sixteenth/seventeenth-century Roman Catholic theology and spirituality.

[38]According to the *Oxford English Dictionary*, the use of *magdalene* for "a reformed prostitute" began in 1697 and for "a home for reformed prostitutes" in 1766.

[39]See Samuel Taylor Coleridge, *Christabel* (c.1797–1801); and John Keats, *La Belle Dame Sans Merci* (1819), and *Lamia* (1819).

[40]For a succinct history of the *femme fatale* see Patrick Bade, *Femme Fatale: Images of Evil and Fascinating Women* (New York: Mayflower Books, 1979); and Bram Dijkstra, *Idols of Perversity: Fantasies of Feminine Evil in Fin-de-Siécle Culture* (New York: Oxford University Press, 1986).

[41]Rénan, a French Orientalist and essayist, scandalized Paris when as Professor of Hebrew at the Collége de France he pronounced that Jesus was an "incomparable man." His emphasis on the humanity of Jesus in the *Vie de Jésus* was consistent with the then emerging "quest for the historical Jesus."

[42]For an in-depth discussion of the relationship between Mary Magdalene and Picasso's *Weeping Women*, see my entry, "Pablo Picasso, *The Weeping Woman*," in *Beyond Belief: Modern Art and the Religious Imagination*, ed. Rosemary Crumlin (Melbourne: National Gallery of Victoria, 1998), 66–67. Further discussion of Picasso's retrieval of Magdalene imagery can be found in my essay, "The Essence of Agony: Grünewald's Influence on Picasso" in *Artibus et Historiae* 26 (1992), 31–48.

[43]Erika Langmuir, *Pocket Guides: Saints* (London: The National Gallery, 2001), 51.

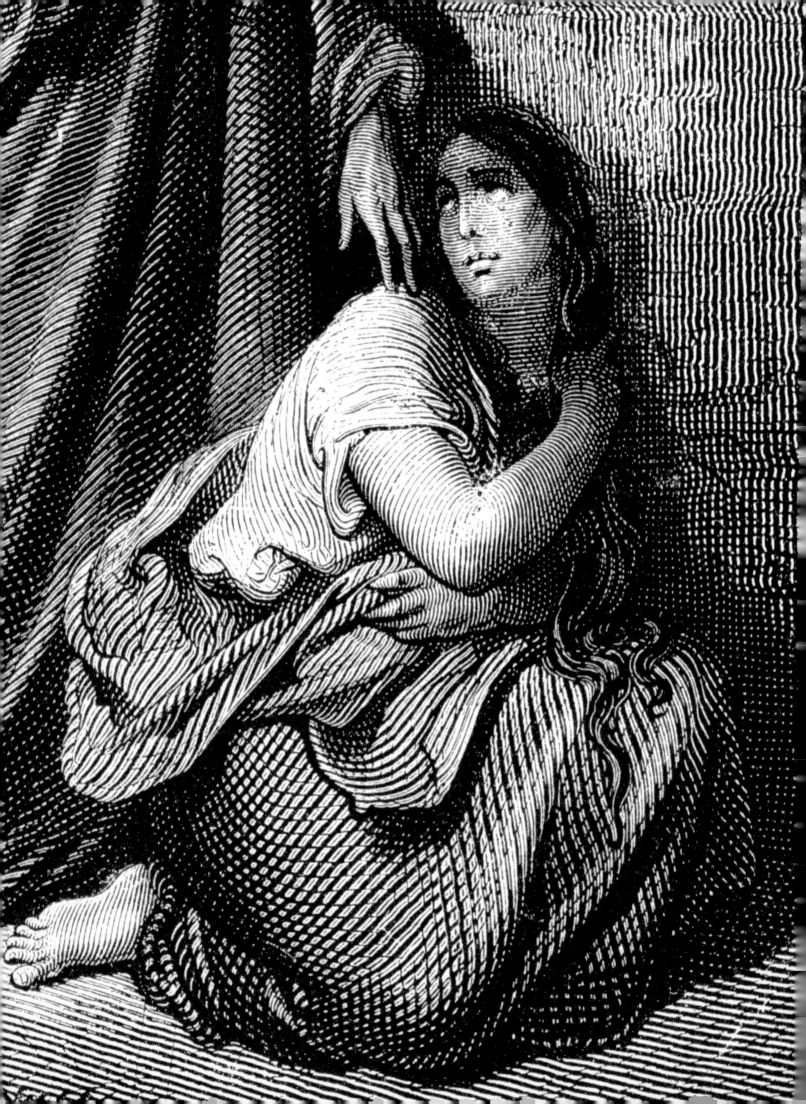

Sinner

SINNER. From the Old English, *synne*, for one who violates divine law; a transgressor against the law of God. The motif of sinner is perhaps the best known later imposed image of Mary Magdalene even though the reality of her sin is never depicted or disclosed. We encounter her during the episodes of accusation, judgment, and pardon. The implication in the post New Testament interpretations, hymns, sermons, and Christian art is that her "sin" is sexual in nature. This assumption, made because she is a woman and thereby "the devil's gateway," becomes the justification for artistic portrayals of her as a beautiful, desirable female figure. Her elegant dress and coiffure combine with the sensual tactility of the perfumed ointments in her jar to heighten the association of her "sin" with sexual licentiousness. Mark and Luke provide the only scriptural accounts for the possible identification of Mary of Magdala as sinner—the woman from whom the seven demons were cast; all the other scriptural references are either to unnamed women or one of the other Marys.[1]

Gustave Doré (French, 1832–1883)
WOMAN TAKEN IN ADULTERY [detail]
From *The Doré Bible Gallery*, New York:
Fine Art Publishing Co., 1879, The
Library at the American Bible Society

The confusion among the multiple "Marys" and several unnamed women in the scriptural narratives proceeded from similarities in their activities, the morals to their stories, or textual proximity. The realities of oral recitation exacerbated the situation by which Mary Magdalene became identified as the anonymous adulteress in the hearts and minds of believers.

The scriptural account of the Woman Taken in Adultery relates the Pharisees' unsuccessful maneuver to

ensnare Jesus in an act of blasphemy that would effectively terminate his ministry (John 8.1–11). An unnamed woman, ostensibly apprehended in the act of adultery, was brought before him for judgment according to the Mosaic law (Leviticus 20.10; Deuteronomy 22.22–24). Cognizant of the double-edged sword—the punishment for adultery was death by stoning according to the religious code while Roman law permitted only Roman judges to sentence death—Jesus replied initially with silence as he bent down and with his finger began to write on the ground (John 8.6). He advised both the Pharisees and the surrounding crowd that the one among them without sin must cast the first stone. Once he completed writing, he straightened up and saw only the woman. The absence of her accusers absolved the woman of the charge and the ensuing condemnation. Thereupon, Jesus announced that neither would he judge her and sent her home.

The theme of the Woman Taken in Adultery has two modes of depiction in Christian art: the visual drama of the confrontation sequence is heightened by the singularity of Jesus writing while the exoneration scene is the more prevalent image. The otherwise unnamed adulteress, once she becomes identified with Mary Magdalene, is often characterized by her red hair and stylish attire and her placement either at his feet or looking down on them. Jesus turns toward her as his gestures communicate the void left by her accusers and his pardoning of her sin.

The theme of the Woman Taken in Adultery was popularized by the fifteenth-century artist Michael Packer who shifted the viewer's attention to the accusation scene. John the Evangelist is not forthcoming as to what or why Jesus wrote on the ground. The accustomed interpretation is that he spelled out either the names or the sins of her accusers while the artistic convention has him inscribing the scriptural dictum in Latin, "*Qui sine peccato est vestrum, primus in illam lapidem mittat*," "He that is without sin among you, let him first cast a stone at her."

Whether correctly identified as images of the unnamed adulteress or implying Mary Magdalene, representations of this scriptural episode became a popular form of visual pedagogy for Christian ethics and for appropriate female behavior. Book illustrations and prints were the most financially accessible artistic media for the Christian collective. All four exhibited works illustrating this scriptural motif represent this visual idiom of moral education in the readily available print media of "lady's annuals," illustrated Bibles, and prints.

Gustave Doré was one of the nineteenth-century's most prolific and popular illustrators. He was especially renowned for his biblical images such as *Woman Taken in Adultery* (fig. 13). His carefully rendered academic presentations of scriptural narratives were replete with dramatic moments, elaborate costumes, spectacular architectural settings, theatrical lighting, and melodramatic crowds. These are the visual predecessors of the cinematic biblical epics popularized by Cecil B. De Mille. Doré created his most famous series of biblical illustrations in 1866 just prior to opening a gallery dedicated to the display and sale of his works on London's Bond Street. A commercial and critical success, the Doré Gallery assured a wider public recognition of the artist's vision. His depictions of the Christian narrative found their way into a variety of editions of the Bible including the 1879 imprint on view in this exhibition.

In his illustration for the *Woman Taken in Adultery*, Doré fashions a traditional presentation in which the central figure of Jesus is the mediator between accusation, justice,

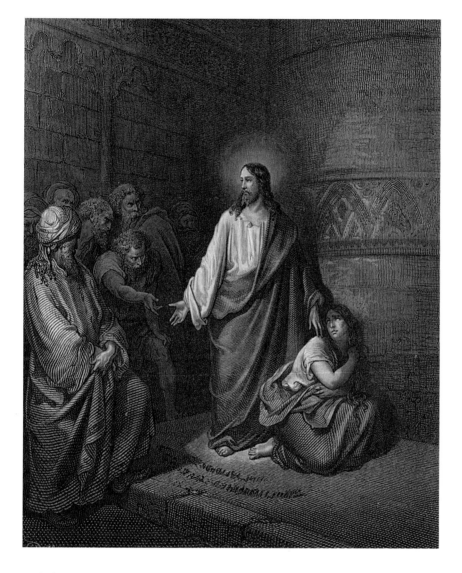

Figure 13. Gustave Doré (French, 1832–1883) WOMAN TAKEN IN ADULTERY
From *The Doré Bible Gallery*, New York:
Fine Art Publishing Co., 1879, The Library
at the American Bible Society

and forgiveness. Jesus and the anonymous adulteress are situated on an elevated platform.[2] The body language of "the mob" expresses anger and wrathful justice while the impressive figure of the turbaned Pharisee stands in the foreground. As the viewer's eye moves from the Pharisee's right foot diagonally to the platform, we see the inscription and transfer our attention from Jesus' foot to the woman. Her crouching, frightened figure seeks protection from the man who gently rests his left hand on her shoulder. Her long hair flows down her torso as her hands strive to secure her garments, perhaps implying an attempt to "cover up" her sinful state. She is positioned at the feet of Jesus—the location we are accustomed to look for Mary Magdalene in the unction narratives, the contemplative lesson, the crucifixion account, the lamentation, or most especially, the *Noli Me Tangere*.

[1] See the earlier discussion in this catalogue, 10–14.

[2] Both have bare feet referencing God's command to Moses to remove his shoes as he stood on holy ground

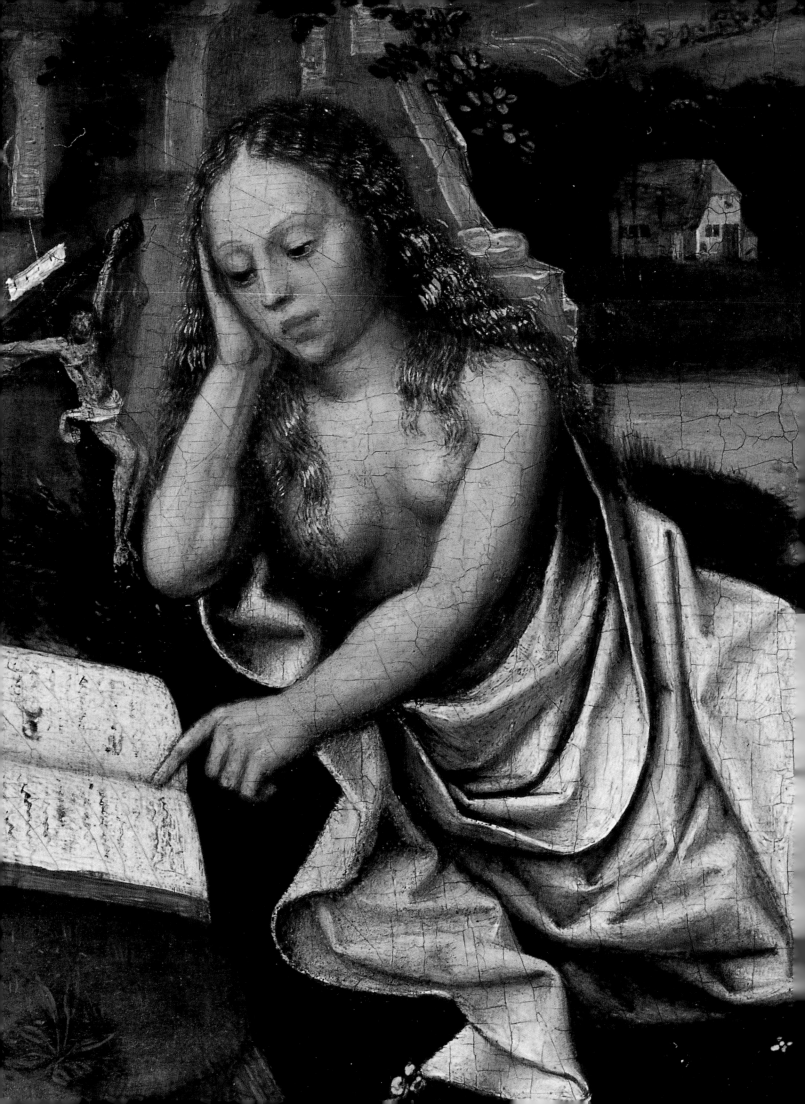

Penitent

ENITENT. From the Latin, *paenitens*, for one who feels pain or sorrow for sins or offense, thereby one who can be forgiven. While Luke and John provide the biblical basis for the forgiven female sinner neither offered a description of the female penitent. Matthew characterizes the male paradigm of penitence, Peter, as having "wept bitter tears" (Matthew 26.75). Nonetheless, the post New Testament believer and theologian alike understood that prior to the receipt of the gift of forgiveness the anonymous sinner of Luke and the nameless adulteress of John expressed remorse. Once Mary Magdalene was identified as both sinner and saint by Pope Gregory in the sixth century, her penitence garnered spiritual significance. Pious legends and traditions, especially throughout the Middle Ages, affirmed her continuing acts of penitence even into the desert, the wilderness, the city of Ephesus, and the forests of France, or wherever the Christian collective identified her presence.

Mary Magdalene understood and articulated her Christian metanoia by means of the sign of her humanness—her body. Images of the penitent Magdalene instructed by example: her profound contrition warranted absolution. Metanoia led to metamorphosis as the sinner began her transformation into saint—visually signaled as the elegantly attired and coiffed woman transformed into the contorted, tearful, and disheveled figure of anguished remorse.

The early Christian theology of tears espoused by Tertullian, Athanasius (c. 295–373), John Cassian (c. 360–c. 435),

Ambrose, Augustine, and most especially, John Climacus (579–649), communicated the principle that tears were the visible but silent symbol of the purification of the soul. "Tears," Ambrose wrote, "are marks of devotion, not merely products of grief."[1] During the Middle Ages, spiritual weeping was revived with the emergence of lay spirituality and devotions which advocated personal experience as the cornerstone of faith. Bernard of Clairvaux affirmed tears as the visible sign of the love of God while the mystic Mechtild von Magdeburg (c. 1209–c. 1282/94) voiced a metaphysical explanation of tears as the propagation of God's grace. The image of the Magdalene as penitent became the exemplary vehicle for the salvific nature of penitential tears.

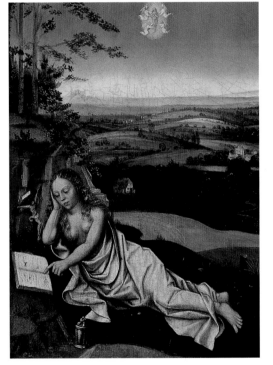

Figure 14. Adriaen Isenbrant (Flemish, c. 1500–1551), THE PENITENT MAGDALEN Oil on panel, Gift of Mrs. Berry v. Stoll, 1967.22, Collection of The Speed Art Museum, Louisville, Kentucky

Adriaen Isenbrandt, the sixteenth-century Flemish artist, painted two exquisite works of the Penitent Magdalene, one of which is in this exhibition (fig. 14). He incorporated the fundamental iconography of the Magdalene as reader and weeper from the earlier works of Rogier van der Weyden (fig. 9). He expanded this iconography by moving her from an ecclesiastical or domestic setting into "the wilderness."[2]

Isenbrandt divided the landscape to emphasize the rock formations and the cave as described in the medieval legends. He reconfigured the seated or kneeling figure of the Magdalene illustrating her reclined upon the earth like a classical goddess. He reduced her elegant garments and headdress to a simple, almost classical, drape which reveals, while attempting to conceal, her physicality. Her hair cascaded down her shoulders onto her bare breasts. With her left index finger she pointed to her text, presumably meditating on its meaning. Her unguent jar identified her as the anointer of the crucified and as the first witness to the Resurrection. In the upper right, Isenbrandt inserted a visual clue as to how to "read" this painting. For the first time within the context of this theme we find the elevation of Mary Magdalene signifying that her meditation on her sins will culminate in her salvation due to the passion, death, and resurrection of Jesus Christ.

The German artist, Albrecht Dürer, produced a popular image of the penitent woman in *Mary Magdalene Carried to Heaven* (fig. 15). Economical and mass produced, woodcuts such as Dürer's made art accessible to all classes. While broadening the artist's audience and popularity, printed works such as woodcuts and engravings magnified the possibility of a personal relationship with religious imagery. Dürer's woodcuts were sold in marketplaces and art shops. Affordability combined with accessibility provided the visual means for the salvation of "everyman."

Derived from sources such as Jacobus de Voragine's *The Golden Legend*, this episode in the post-scriptural life of the Magdalene continued her conflation with the other famed prostitute-turned-hermit saint, Mary of Egypt.

Both women withdrew from active existence into the "wilderness"—the desert for the Egyptian and the South of France for the Magdalene. They maintained exemplary penitential lives—their days consumed in prayers, contemplation of their sins, and meditation on the meaning of salvation. The fashionable garments of the reformed Alexandrian deteriorated into nothingness but her previously styled tresses grew long enough to cover her "nakedness" before God. According to tradition, Mary Magdalene was elevated daily during each of the seven canonical hours. Cherubs descended from the heavens to raise aloft the woman identified previously as "fallen." During her years of penitential withdrawal, the Magdalene was reported not to have eaten earthly food but to have survived from either the celestial music of the canonical hours or the manna offered by the angels.

Dürer depicted the Magdalene on her final earthly elevation as she hovers over rock formations intimating her cave retreat. Immersed in prayer, her corpulent nude body is supported by cherubs strategically located at her feet, torso, and shoulders. In the lower left is the priest who became her emissary to Bishop Max-iminus (first century according to legend) who administered her Last Communion. Despite the absence of any attribute, Dürer's Magdalene is identifiable from her flowing hair and penitential posture.

Carlo Dolci's variations on the Penitent Magdalene (fig. 16) were painterly metaphors for the sacrament of penance. Reformers such as Martin Luther (1483–1546) and John Calvin (1509–64) questioned the meaning of the sacrament and the Roman teachings on the forgiveness of sins. The Magdalene as envisioned by Dolci and other Italian Baroque painters endorsed the Roman Catholic teaching on and practice of the sacraments, especially penance. She embodied Christian metanoia and attested to the metamorphosis of body and soul.

Dolci's teary-eyed Magdalene is absorbed in prayer as conveyed by the gesture of her entwined hands and the upward tilt of her head. Her abundant hair tumbles down her shoulders as a visual counterpoint to her bared arms. The tension within her bodily posture communicates anxiety trapped between hope and despair. The jar is placed prominently as her attribute and the angular focus

Figure 15. Albrecht Dürer (German, 1471–1528) MARY MAGDALENE CARRIED TO HEAVEN, 1504–1505, Woodcut
The Art Museum, Princeton University
Gift of Frank Jewett Mather, Jr.
x1935-1468

between the skull and her entreating hands and face. Dolci's *The Penitent Magdalene* visualizes Émile Mâle's admonition that she was "Beauty consuming itself like incense burned before God in solitude far from the eyes of men [sic. which] became the most stirring image of penance conceivable."[3]

Elihu Vedder, the nineteenth-century American artist, created a series of 50 drawings as visual accompaniments for the acclaimed 1894 edition of the *Rubáiyát of Omar Khayyám*. This exhibited text is opened to the illustrations for quatrains 79 through 81 in which the famed poet

voices the lament of the archetypal penitent trapped by temptation, fallen into sin, and in search of hope. Vedder parallels his lamenting Magdalene to a stunning presentation of Eve as sinner—standing with regal grace as she offers the apple with her right hand. Her right arm is entwined simultaneously with her exuberant hair and the almost invisible serpent who extends his body behind and below Eve as his tail wraps around the tree. The lushness of Eden contrasts sharply with the desolation of the Magdalene's environs. However, the spider's web placed between Eve's apple-proffering hand and the poetic verse is a visual omen of doom.

The almost circular form of the crouching nude woman encased in swirling drapery is Vedder's *The Magdalen* (fig. 17). Her stylized hair and left hand gesture combine with the barren landscape to revive our collective memory of Mary Magdalene in Christian art. Her dramatic posture is reminiscent of Caravaggio's *Penitent Magdalene* (fig. 10) who had flung her jewels to the ground while Vedder's figure has only stones to cast in a visual pun on John 8.7. Her sins are dispersed as she laments her past and dreads her future. Her uncovered unguent jar like Pandora's unlidded box is the repository for Hope.

Figure 17. Elihu Vedder THE MAGDALEN, 1883–1884 (Illustration for Rubáiyát of Omar Khayyám), Chalk, pencil and ink on paper, 1978.108.42, Museum purchase and gift from Elizabeth W. Henderson in memory of her husband Francis Tracy Henderson. Smithsonian American Art Museum, Washington, DC / Art Resource, NY

[1] As quoted in James Elkins, *Pictures and Tears* (New York: Routledge, 2001), 150.

[2] The French iconographer, Louis Réau, identified Mary Magdalene as the "pendant" of Jerome. Isenbrandt's topos of the penitent Magdalene reading and weeping in the wilderness paralleled the contemporary artistic development of this location for Jerome.

[3] Émile Mâle, *Religious Art from the Twelfth to the Eighteenth Century* (New York: Noonday Press, 1970), 171–72.

Figure 16. Carlo Dolci (Italian, 1616–1687)
THE PENITENT MAGDALEN, c. 1670
Oil on canvas, Museum Purchase
1958.19, Davis Museum and Cultural
Center, Wellesley College, Wellesley, MA

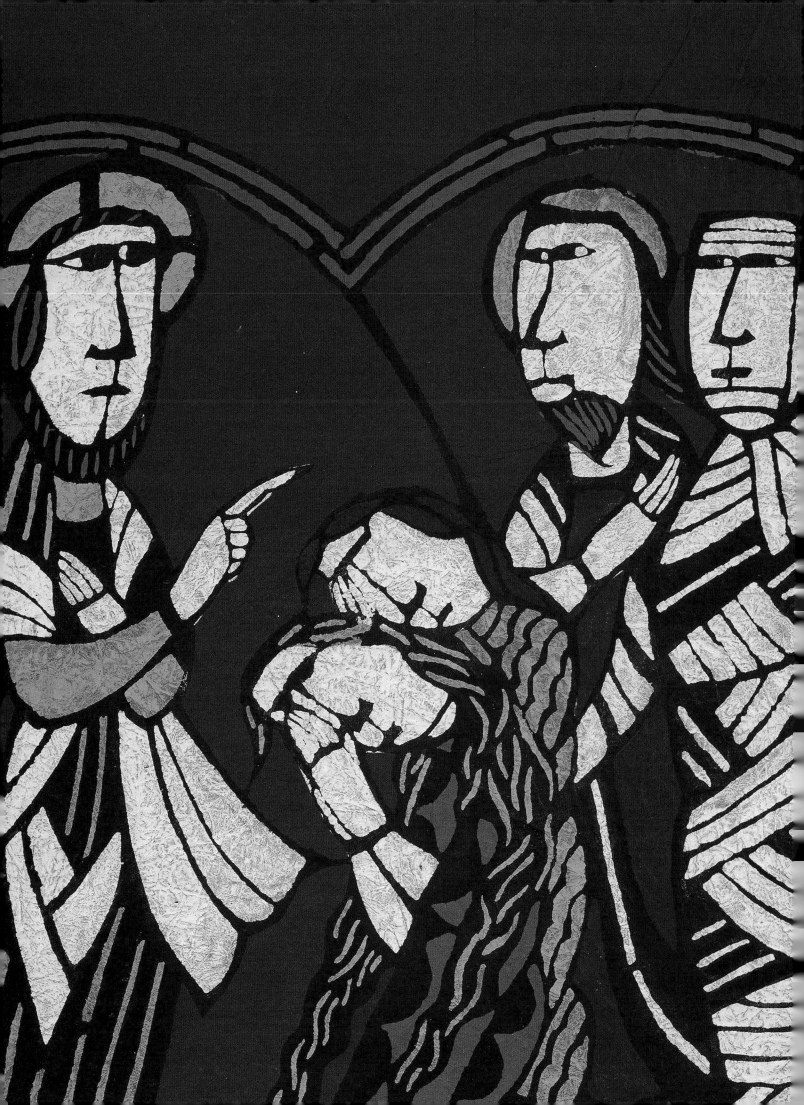

Witness

W ITNESS. From the Greek, *martyr*, for one who beholds or otherwise has personal knowledge of something, and who attests to a fact, event, or testimony. Early Christians identified Mary Magdalene as the first witness of the Resurrection. With her singular flexibility, she performs the role of witness in a variety of capacities. The scripturally identified Mary of Magdala healed from demonic possession, faithfully stands at the foot of the cross, as a potential anointer, and soon-to-be named "apostle to the apostles." Following her much later conflation with the anonymous women and the "other Marys," she testified as a reformed adulteress, the forgiven anointer, the observer of Lazarus being raised, and the attentive student. The common connectives throughout all these scriptural and devotional episodes is that as witness Mary Magdalene needs only to *see* in order to believe. She is the interlocuter between the sacred mystery of belief and the Christian collective.

Watanabe Sadao (Japanese, 1914–1996)
THE RAISING OF LAZARUS [detail], 1981
Katazome stencil print
From the collection of Anne H. H. Pyle
Courtesy of Ms. Harue Watanabe

As one of "The Three Marys," the Magdalene entered into early Christian art and devotion as a witness to the Resurrection. The story of the holy women bearing aromatic ointments to anoint the body of the crucified Jesus but finding an empty tomb is related by all four Evangelists (Matthew 28.1–8; Mark 16.1–8; Luke 24.1–11; John 20.1–9). From the third-century fresco at Dura-Europos to the fifth-century mosaics of Ravenna, the iconography of Three Marys[1] gives visual witness to the reality of the biblical accounts and to the gender parity of early Christianity. Under normal circumstances a woman's declaration was not

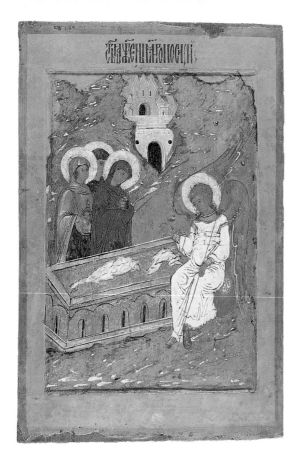

Figure 18. THE MYRRHBEARING WOMEN
AT THE TOMB, Russian, 16th century
Courtesy of St. Vladimir's Seminary
Press, Crestwood, NY

Figure 19. RAISING OF LAZARUS and
NOLI ME TANGERE, Gothic casket
Italian, last quarter of 14th century
Collection Michael Hall Esq.

recognized under Jewish law, however, the corroboration of two (or more) witnesses was accepted as valid testimony.

Eastern Orthodox Christian tradition identifies the *Myrrophori*, "Myrrhbearing Women," as the original icon of the historical event of *Pascha*, "Easter,"—the discovery of the empty tomb. The acknowledged iconography of the *Anastasis*, "Resurrection," had two biblical elements: the *Myrrophori* and the Descent into Hell. While both of these icons were utilized during the Paschal liturgies and for acts of personal devotion, they had differing emphases—the *Myrrophori* identified the historic event of the Resurrection, the Descent into Hell its salvific effects.

The *Myrrhbearing Women at the Tomb* (fig. 18) depicts the Holy Women—usually identified as Mary Magdalene, Mary the wife of Cleophas, and Mary Salome—bearing jars of aromatic ointments to anoint the crucified body of Jesus. They enter "stage left" to find the tomb empty, the burial linen discarded, and an angel[2] with his right hand raised in greeting. In the background is the barren, rocky landscape with a central opening towards the Heavenly Jerusalem. The figure identified as Mary Magdalene bows her head respectfully to both the empty tomb and the angel. She *witnesses* the mystery of the Resurrection and believes.[3]

> O ye *blind* unbelievers, deceivers and transgressors,
> who disbelieved Christ's arising as though it were a
> lie: What do you *see* that is unbelievable? That Christ,
> Who raised up the dead is risen?[4]

From the late twelfth century forward, Byzantine iconographers incorporated the *Theotokos*, "Mother of God," within the *Myrrophori* icons. Although there is no scriptural basis for her inclusion, pious devotion promoted her presence as one of the first witnesses to the Resurrection. The fourteenth-century church father, Gregory Palamas (1296–1359), affirmed this tradition.[5] The *Theotokos* is designated by her position in front of

the Magdalene and also by the inscribed letters 9X-1K.[6] During the sixteenth century, Byzantine iconographers expanded their accustomed boundaries to introduce the western Christian topic of the *Noli Me Tangere.*

The exceptional casket (fig. 19) included in this exhibition demonstrates the unity through multiplicity of the motif of the Magdalene as witness. The two lower registers on the front and back follow the convention of Christian typology in which images relate as foretype to type.[7] The front exhibits the narrative of the *Raising of Lazarus* (John 11.1–44) in an established composition: the crowd of onlookers is on our left while Lazarus still bound in burial wrappings emerges from the coffin on our right. Our attention is drawn to the three persons in the center: Jesus with his right hand in a thaumaturgic gesture and two kneeling women identified as Martha and Mary of Bethany, the sisters of Lazarus. From the sixth-century Gregorian pronouncements, western Christians accepted the conflation of Mary of Bethany with Mary of Magdala. Her

pose and placement—kneeling at the feet of Jesus—assist our immediate identification of her along with the sumptuous red mantle that covers her body. On the reverse of the casket is a depiction of the *Noli Me Tangere*—the type of Christ's Resurrection which fulfills the foretype of the Raising of Lazarus—and the Magdalene commandeers her rightful location in the center of the visual composition and of the narrative. Clad in her familiar red mantle, she kneels at the feet of the now Risen Christ. This is her place as the witness who believes because she has *seen.*

Watanabe Sadao, the twentieth-century Japanese artist, incorporated biblical imagery into the tradition of Japanese *katzazome* paste-resist stencil dyeing.[8] *The Raising of Lazarus* (fig. 20) features a kneeling Magdalene whose hair flows down her shoulders. One particularly lengthy tress touches Jesus' left foot creating a physical connection between them. She bows her head and clasps her hands by her eyes to capture her tears as Jesus makes a healing gesture toward the wrapped figure of

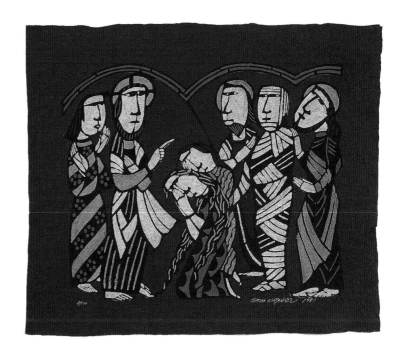

Figure 20. Watanabe Sadao
(Japanese, 1914–1996)
THE RAISING OF LAZARUS, 1981
Katazome stencil print
From the collection of Anne H. H. Pyle
Courtesy of Ms. Harue Watanabe

Figure 21.
Wendy Brusick Steiner (American, b. 1956)
I'VE SEEN LOVE CONQUER THE GREAT
DIVIDE, 1989, Oil on canvas, Sloan Fund
Purchase/Anonymous FRIENDS Purchase
Brauer Museum of Arts, 89.24
Valparaiso University, [bottom right]

Lazarus. Watanabe's Magdalene is the conduit between the physical and spiritual meaning of the miracle of life, particularly the life made possible through faith.

Wendy Brusick, the contemporary American artist, continues the Gregorian model of the Magdalene in her riveting canvas, *I've Seen Love Conquer the Great Divide* (fig. 21). Having spent several months viewing the masterpieces of Christian art in European museums, Brusick encountered Vincent van Gogh's re-interpretation of a famous religious painting.[9] Influenced by his "re-invention" of a classic work, she sought to retrieve the Entombment through a diligent study of Christian art and a commitment to her own artistic vocabulary.

Her composition of *I've Seen Love Conquer the Great Divide* retains the somber lament of earlier paintings of the Entombment. The crucified body dominates the space. Brusick redefines the usual "cast of characters"—Mary the Mother, Mary Magdalene, Mary wife of Cleophas, and Joseph of Arimathea—through her own painterly idiom. She incorporated photographs of friends for the figural characters and from her travels through Ireland into "…the background reference with a broken stone fence symbolizing the breakthrough and triumph of Christ over death." Her new element is the "symbol of innocence shattered"—an eerily calm young child holding the crucifixion nails as she sits underneath the table bearing the crucified body.

Mary the Mother stoically performs the task of wrapping her child's body in his burial shroud. Joseph of Arimathea cautiously removes the crown of thorns. Comforted by the green-clad Mary wife of Cleophas, the purple-clad Magdalene assumes her familiar position at Jesus' feet. "She cradles the dead Christ's feet, her hair draping across his legs in an allusion to her story of anointing Jesus's feet with oil and drying them with her hair. She represents human suffering from loss." As the vehicle for the emotional paradoxes which are *beyond* language, the Magdalene embodies the discourse of lamentation as she witnesses collective despair.

52

[1] The Evangelists and thereby Christian artists differ on the number of women—Matthew identifies two women (Matthew 28.1); Mark names three women (Mark 16.1); Luke employs the ambiguous "they" (Luke 24.1); and John designates only Mary Magdalene (John 20.1).

[2] As with the varying number of the "Holy Women," there is no clear agreement as to the number of angels at the Empty Tomb.

[3] Thomas' empirical need to touch in order to believe contrasts sharply to the Magdalene's faith affirmed by *seeing*. This engendered comparison is emphasized in the western Christian iconographies of the *Noli Me Tangere* and the *Doubting Thomas*.

[4] *Matins, Ode 8, Tone 2* for the Sunday of the *Myrrophori*. The italicized emphasis is mine.

[5] Palamas' homiletic text was quoted in the later western Christian iconography of the Risen Christ Appearing to His Mother.

[6] For the Greek, *Meter Theou*, "Mother of God."

[7] The foretype is the mythological, Hebrew Scriptural or Christian Scriptural figure who will be fulfilled in the type who is Jesus Christ or Mary. See my *Dictionary of Christian Art* (New York: Continuum Publishing, 1994), 7–8, 135.

[8] Anne H.H. Pyle, "A Chrisitan Faith in the Tradition of Japanese Folk Art," in *Printing the Word: The Art of Watanabe Sadao* (New York: American Bible Society, 2000), 17.

[9] From the "Artist's Statement" referencing her works on display at Valparaiso University. All quotes from the artist are excerpted from this document.

Contemplative

CONTEMPLATIVE. From the Latin, *con* + *templum*, meditation on spiritual things; the act of considering by attention, musing, study. This motif developed from the Lucan account of Lazarus' two sisters, Martha and Mary, as female metaphors of the active and contemplative lives. When Jesus came to their home in Bethany, Mary attended to spiritual instruction at his feet. Martha had to complete all the necessary household duties alone.

When she voiced her displeasure, Jesus replied that Mary had chosen the better part. The personification of the active life, Martha was characterized by pragmatism, efficiency, domesticity, and industriousness. The embodiment of the contemplative life, Mary exemplified spirituality, quietude, tranquility, and otherworldliness. Once the two Marys—of Bethany and of Magdala—were conflated long after the New Testament period, depictions of the Magdalene as a contemplative balanced the emotively charged images of her mourning at the foot of the cross (fig. 6) or the entombment.

The act of reading is an encounter with a silent world of ideas, an experience of introspection; thereby the Magdalene as reader manifested contemplation. The medieval perception of reading was explained through the then-common metaphor of the book as food—the reader ruminated carefully to digest the masticated text. She assimilated and then eliminated the text. To the medieval mind, this bodily elimination was significant as it was only possible once the *meaning* of the text had been absorbed—the excretion was the longed-

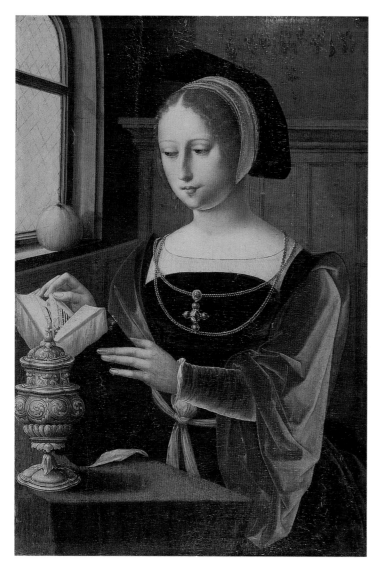

for devotional vision. Medieval depictions of a reader engaged in meditation upon a text are deceptive to modern eyes for the surface beauty is subordinate to the radiance of the reader's vision. If the medieval picture of the reader is an *exemplum*, that is a moralizing image, then the inclusion of her vision demonstrates the lesson as in Adriaen Isenbrandt's *The Penitent Magdalen* (fig. 14).

During the Middle Ages, readers formed personal relationships with their books, most especially with those illustrated texts which permitted access to contemplation. Illuminated prayerbooks, such as Books of Hours, were personalized to fortify individual meditative practice. The emerging lay devotional movements such as the *Devotio Moderna* and the Brotherhood of the Common Life advocated literacy and affordable devotional books. In her pioneering essay on "Medieval Women Book Owners," historian Susan Groag Bell affirmed the value of Books of Hours for medieval women readers whose "public participation in spiritual life was not welcomed by the hierarchical male establishment, a close involvement with religious devotional literature, inoffensive because of its privacy, took on a greater importance for women."[1]

Rogier van der Weyden's *The Magdalen Reading* (fig. 9) is the first known depiction of her as reader. His iconographic innovation found favor among the Christian community, especially in the northern countries, and established an artistic vogue for this theme.[2] The exquisite painting by the Master of the Parrot, *Portrait of a Noble Lady Reading Her Prayer Book* (fig. 22), is a visual paraphrase for the Magdalene as reader.[3] His Magdalene as an anonymous noble lady references simultaneously her less-than-pious early life and her later Christian dedication. She is dressed in elegant velvet, precisely styled to accentuate her feminine attributes with the wide décolletage, fitted bodice, puffed shoulders, and copious sleeves. Her headpiece, appropriately fashionable in velvet with jewel-encrusted brocaded trim, rests securely, but far back enough upon her head to reveal her well-mannered but magnificent hair. Her delicately-manicured hands are highlighted by her elongated fingers in which she holds her Book of Hours. An elaborate cross hangs from one of her golden chains as she kneels at her prie-dieu to meditate upon her text. The carefully detailed interior space which surrounds her implies the intimacy of a prayer closet interrupted only by the strategically placed clear-glass window to our left.

The artist has aligned the three significant devices—an ornate vessel, a Book of Hours, and a pomegranate—in a tiered procession moving upwards from the lower left corner toward the window. This carefully situated confluence argues for their coordinated reading of the subject of this painting as the Magdalene. The opulent covered jar is the Master of the Parrot's version of the renowned attribute symbolic of the Magdalene's role as anointer. Her Book of Hours signifies the daily spiritual devotions of the medieval Christian. The pomegranate is a botanical symbol whose many seeds and red juice encased within a thick skin has multiple Christian references including the church, the unity of all Christians through the Eucharist, and the Resurrection.[4] If we apply the medieval sense of the book as food and the spiritual import of a vision, then we could interpret these three devices as identifying the sitter as the Magdalene. Her ointment jar indicates that she was the first witness to the Resurrection; her Book of Hours that she was the paradigm of the contemplative life; and the pomegranate that she meditated upon the salvific meaning of the Resurrection.

The tranquility and otherworldly qualities of the contemplative motif are displayed in the nineteenth-century German sculpture of the *Magdalene Holding a Jar* (fig. 23). This statue is related to those late medieval sculptures and fifteenth and sixteenth-century prints of the Magdalene as an individual seemingly removed from a particular scriptural or legendary narrative. This graceful but thoughtful figure clutches her precious ointment jar with her right hand. Her lavish hair extends beyond the confines of her veil to flow down her right shoulder and back. Her inner quietude exudes from her calm composure in an encounter as consoling as Christian anointing. The classical perception of the affinity between physical and spiritual healing is transmitted to the Christian sacraments of chrismation and unction. Not simply the preserve of the dead and dying, holy anointment is the Christian ritual seal of spiritual solace and protection. This refined sculptural interpretation of the Magdalene proffers a similar ambience for her audience. *Magdalene Holding a Jar* references not simply the multiple biblical unction episodes but may be related to the apocryphal account in which "the old Hebrew woman" placed the foreskin (or "navel-string") of the recently circumcised Jesus in an ointment jar filled with nard to preserve it. This same jar was purchased by "Mary the sinner" for his anointment.[5] Thereby, image and story merge into

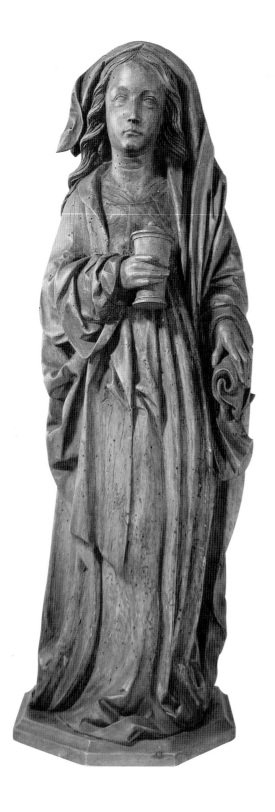

a ritualizing act which clarifies what had been previously obstructive for the soul.

The nineteenth-century painting, *Saint Magdalen Reading* (fig. 24), draws our attention to the sum and substance of the reproduction of an image. This charming painted re-presentation of the sixteenth-century original extends the fascination with the Magdalene as reader into American cultural history. Once again, she is depicted as a full-bodied female figure with magnificent hair streaming down her bare shoulders to delicately cover her otherwise naked bosom. She is wrapped in a blue silken mantle as she lounges on the earth, her bare feet balancing her bare shoulders. She props her head on her right hand as she supports her opened book with her left hand. In the foreground is a skull, the symbol

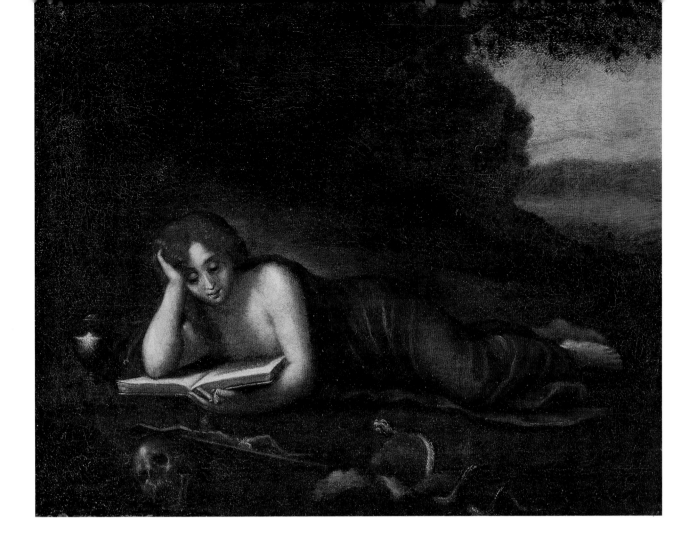

of the transitory nature of human existence, while to her right is her ever-present unguent jar. All this within the pastoral setting the American Eden.

This alluring image of a beautiful woman in a lush environment is not an exact copy of Correggio's painting; his Magdalene is a blonde who cradles her bosom instead of her book. The exhibited illustrated page from the nineteenth-century annual, *The Gem of the Season*, is closer to the original painting. The careful observer will see the variations of the Magdalene as reader displayed in this exhibition from the paintings of Isenbrandt and the Master of the Parrot to the illustrated page of the *Penitent Magdalene Reading in the Wilderness*, Book of Hours (Bourges), early 16th century, to the selected pages from illustrated Bibles and Annuals.

[1] Susan Groag Bell, "Medieval Women Book Owners: Arbiters of Lay Piety and Ambassadors of Culture," *Signs* 7.4 (1982).

[2] Ambrosius Benson, Isenbrandt, and the Master of the Female Half-Lengths produced a corpus of paintings of the Magdalene reading, see Max J. Friedländer, *Early Netherlandish Painting* (New York: Praeger Publishing, 1967); 7: pl. 148, 175; 12: pl. 42.

[3] This painter's identifying epithet connotes his scrupulous renderings of the exotic bird in his Madonna and Child panels; see Friedländer, *Early Netherlandish Painting*, 12-20.

[4] Diane Apostolos-Cappadona, *Dictionary of Christian Art* (New York: Continuum, 1994), 280.

[5] *The Arabic Gospel of the Infancy of the Saviour*, Chapter 5. I am grateful to my student, Daniel G. Callahan, for calling my attention to this story.

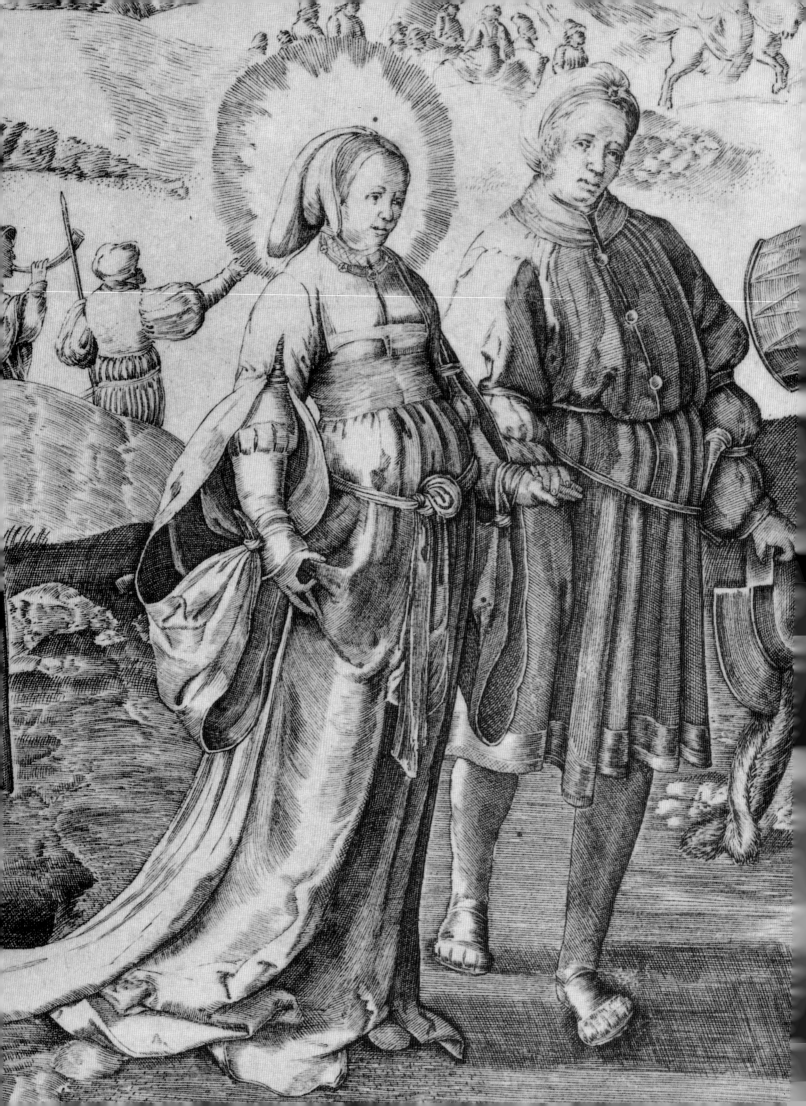

Muse

USE. From the Greek, *mousa,* for the inspiring goddesses of the arts and sciences, and for a state of profound meditation; from the French, *muser,* for to ponder, to dream. The motif of "muse" like the Magdalene herself is ambiguous and flexible for the identical combination of letters proffers both a noun and a verb. This artistic theme elucidates the forms and shapes that contribute to our continuing fascination with the sinner-turned-saint. Although there is no direct biblical basis for her iconography as "muse," it is through this female figuration that the Christian collective continues to identify with Mary Magdalene.

At first glance, Lucas van Leyden's *Dance of St. Mary Magdalene* (fig. 25) gives the impression of being a secular genre scene in the guise of "religious art" while its thematic relationship to "the arts" implies a connection with the Magdalene as muse. The initial visual emphasis on the stylishly-garbed couple striding to center stage intimates that this is a courtship scene. Throughout the foreground other couples are interspersed in varying stages of embrace as a pair of musicians perform under a tree-shaded space. Medieval and Renaissance courtship included *basse* dances and lute music; several

such compositions were dedicated to the Magdalene.[1] Van Leyden has moved beyond the medieval renderings of her enrapt in spiritual ecstasy as she listens to the heavenly chorus toward the *mondaine courtesan* of secular music and dance. The allusions to sexuality ever present in the metaphor of the dance are made explicit in the standing trio at the left middle ground. This composition of an older and a younger woman with a man connotes more than a gathering of friends. The matron extends her right arm across the upper torso of the maiden toward the man whose right arm is posi-

tioned behind his "purchase." The maiden's right arm parallels that of the matron as her open right hand rests gently upon his chest while her left hand gestures provocatively. These visual clues combined with the identification of the once demonically possessed Mary of Magdala as the anonymous adulteress and the unnamed sinful anointer substantiate the initial reading of this image within the late fifteenth-century iconography of the love garden.[2]

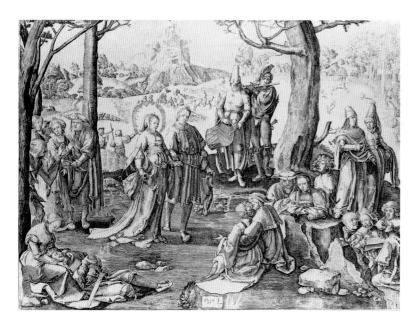

Figure 25. Lucas van Leyden (Dutch, 1494–1533), DANCE OF ST. MARY MAGDALENE, 1519, Engraving, Gift of Mrs. Toivo Laminan (Margaret Chamberlin, Class of 1929), 1961.1 Davis Museum and Cultural Center Wellesley College, Wellesley, MA

However, an attentive *seeing* of this complex engraving proffers an entry into the artistic imagination on the eve of the Reformation. The theological conundrum of the Magdalene's "true" identity surfaced once again in the writings of Jacques Lefèvre d'Étaples.[3] The French humanist promoted his conviction that the beloved medieval saint was an erroneous composition of three biblical women. In his treatises, *De Maria Magdalena*, Lefèvre d'Étaples sought to distinguish between Mary of Magdala and Mary of Bethany. From his perspective, the ideal Christian life was one dedicated to consistent contemplation, not to the transformations signified by the sinful-then-saintly figure of

Mary Magdalene. Lefèvre d'Étaples provoked controversy at every level of the Christian collective from the esoteric but public debates between himself and John Fisher, then Bishop of Rochester, to the re-definition of her iconography by northern artists.[4]

Prints, such as van Leyden' engraving, were accessible to a wide audience given the economics of mass production. His presentation of the *Dance of St. Mary Magdalene* offered visual affirmation of her station in both the roster of saints, and in the hearts and minds of believers. Beyond her halo-encased head is a craggy mountain reminiscent of the stylized depictions of her penitential cave in Adriaen Isenbrandt's *The Penitent Magdalen* (fig. 14) and Albrecht Dürer's *Mary Magdalene Carried to Heaven* (fig. 15). Like his Flemish contemporary, van Leyden unites the Magdalene as sinner with the Magdalene as saint within one frame as she is elevated above the rocky peak in the distant background. It was the drama of her conversion—her physical and spiritual move away from human fallibility to Christian salvation—that endeared her to believers. From that privileged preserve she captured the imagination and the devotion of the Christian faithful, and inspired their spiritual journeys.

The Magdalene's interconnections with music are premised upon the devotional legend of her daily elevations at each of the seven canonical hours. She was believed to listen to the chants of the celestial choir. Just as she has traversed iconographic and theological transformations, Mary Magdalene peregrinated the course of western music as musician, dancer, and muse. The ninth-century Byzantine nun, Kassia, com-

posed a chant for *The Fallen Woman*, oftentimes identified as the *Hymn of Kassiani*, sung during the Holy Wednesday services of the Eastern Orthodox Christian churches. Depictions of her playing the lute or the clavichord—instruments previously reserved for the angels—flourished in northern medieval paintings and paralleled the composing of secular *basse* dances and love songs in her honor. Western liturgical music dedicated to the Magdalene, especially for Lenten and Paschal services, is evidenced by the Gregorian chants known as the *Offices of St. Mary Magdalen*, the sixteenth-century *Missa Maria Magdalena* by Alonso Lobo, and the French baroque laments of the *Magdalena lugens* by Marc-Antoine Charpentier for his *Salve Regina*. Operas dedicated to the "courtesan with a heart of gold" like Jules Massenet's historical *Thaïs*, Giacomo Puccini's *Tosca*, and Giuseppe Verdi's *La traviata* are the "secular" descendants of the Magdalene.[5] She inspired sacred and secular music even throughout the twentieth century from Kris Kristofferson's haunting "Magdalene" to Andrew Lloyd Weber's mournful "I don't know how to love him" from *Jesus Christ Superstar* to the Legendary Pink Dots' "Casting the Runes."

The Magdalene has made a comparable pilgrimage through the canons of western literature from drama to poetry to prose. She began her theatrical employment as the supporting actress in early Christian liturgical plays to become a star of medieval dramas. She has maintained a stage presence in both secular and sacred theater even into the twentieth-century. Her poetic pilgrimage which began in the scriptural and apocryphal texts of the earliest Christian communities flourished in the courtly "love" poetry of the Middle Ages. The devotional poetry of the Baroque period found inspiration in Mary Magdalene as evidenced by the verses of Richard Crashaw and John Donne. The

nineteenth-century infatuation with the *femme fatale* discerned her in Samuel Taylor Coleridge's "Christabel" and John Keats' "La Belle Dame Sans Merci." The Magdalene was transformed from the "heroine" of popular legends and medieval devotional literature into the protagonist of modern biblical fiction. She has been featured as the central or a leading character in late nineteenth and twentieth-century novels, novellas, and short stories including the vastly popular *The Road from Olivet* by Edward F. Murphy and *The Galileans* by Frank Slaughter (fig. 26). Predicated upon the Gregorian model, the Magdalene of popular biblical fiction is the well-known female apostate transformed into apostle. A cursory glance at the covers of the "Magdalene fiction" included in this exhibition confirms the popularity of her image as the alluring inamorata—focal point of "the gaze."

Her archetypal presence in popular consciousness established her cinematic career in both biblical epics and "secular" films. The select film stills displayed in this exhibition suggest the endurance the persona of the composite Magdalene from the infamous "scantily-clad" Jacqueline Logan in Cecil B. De Mille's classic *The King of Kings* to the interpretation by Melina Mercouri in Jule Dassin's *Celui Qui Doit Mourir* (*He who must die*). The visual analogy between cinematic depictions and classic Christian art becomes apparent in the costumes and postures of the many actresses who have played "the Magdalene" as fallen woman, sinful anointer, tearful penitent, and radiant witness.

The motif of Mary Magdalene as "muse" inspiring the high arts and popular culture conveys an image of Christian faith that requires our attention. Inspiration even in the creation of "secular" artworks effects the continuing presence of God's grace made accessible by the woman who needed only to *see* in order to believe.

A NOVEL OF MARY MAGDALENE

THE GALILEANS

By the author of THE ROAD TO BITHYNIA

FRANK G. SLAUGHTER

[1] For example, *La Magdalena* by Pierre Attaingnant. The most comprehensive study of the Magdalene theme in medieval and Renaissance music as well as the iconography of the Magdalene as musician is by Colin Slim, see the bibliography in this catalogue, p. 67.

[2] Craig Harbison, "Lucas van Leyden, the Magdalen and the Problem of Secularization in Early Sixteenth Century Northern Art," *Oud Holland* 98 (1984): 119.

[3] For a comprehensive discussion of this theological controversy, see Anselm Hufstader, "Lefèvre d'Étaples and the Magdalene," *Studies in the Renaissance* 16 (1969): 31–60.

[4] A detailed analysis of this new iconography, especially with regard to Lucas van Leyden, is found in Harbison, "Lucas van Leyden." My initial reading of the theme of the "Dance of the Magdalene" benefitted from both Harbison's and Slim's texts.

[5] Diane Apostolos-Cappadona, "Images, Interpretations, and Traditions: A Study of the Magdalene," in *Interpreting Tradition: The Art of Theological Reflection* (Chico: Scholars Press, 1983), 115;120, n. 32.

Figure 26. Book jacket for
THE GALILEANS by Frank G. Slaughter
1953. Doubleday, a division of
Random House, Inc.
Illustration by Franz Felix

ART HISTORY STUDIES

Apostolos-Cappadona, Diane. "Images, Interpretations, and Traditions: A Study of the Magdalene" in *Interpreting Tradition: The Art of Theological Reflection* (Chico: Scholars Press, 1983): 109–21.

Apostolos-Cappadona, Diane. *Dictionary of Christian Art.* New York: Continuum Publishing, 1994.

Apostolos-Cappadona, Diane. *Dictionary of Women in Religious Art.* New York: Oxford University Press, 1998.

Apostolos-Cappadona, Diane. "Essence of Agony: Grünewald's Influence on Picasso" in *Artibus et Historiae 26* (1992): 31–48.

Apostolos-Cappadona, Diane. "Saint and Sinner: Mary Magdalene in Art History" in *US Catholic Magazine.* 64.5 (April 2000): 17.

Apostolos-Cappadona, Diane. "Pablo Picasso, The Weeping Woman" in *Beyond Belief: Modern Art and the Religious Imagination.* Melbourne: National Gallery of Victoria, 1998: 66–67.

Barasch, Moshe. "The Crying Face" in *Artibus et Historiae 15* (1987): 21–36.

Bardon, Françoise. "Le Théme de la Madeleine Pénitente au XVIIeme Siécle en France" in *Journal of the Warburg and Courtauld Institutes 31* (1968): 274–302.

Berger, John. *Ways of Seeing.* New York: Penguin Books, 1979 (1973).

Blum, Shirley Nielsen. "Symbolic Invention in the Art of Rogier van der Weyden" in *Konsthistorisk Tidskrift 46.3* (1977): 103–22.

Cartlidge, David R. and J. Keith Elliott. *Art and the Christian Apocrypha.* New York: Routledge, 2001.

Clark, Kenneth. *The Nude: A Study in Ideal Form.* Princeton: Princeton University Press, 1984 (1956).

Clement, Clara Erskine [Waters]. *Heroines of the Bible in Art.* Boston: L.C. Page and Company, 1900.

Clement, Clara Erskine [Waters]. *Saints in Art.* London: David Nutt, 1899: 297–336.

Davies, Martin. *Rogier van der Weyden.* London: Phaidon Press, 1972.

Davies, Martin. "Rogier van der Weyden's Magdalen Reading" in *Miscellanea Prof. Dr. D. Roggen.* Antwerpen: Uitgeverij de Sikkel, 1957: 77–89.

Dillenberger, Jane Daggett. "The Magdalen: Reflections on the Image of the Saint and Sinner in Christian Art" in *Image and Spirit in Sacred and Secular Art.* New York: Crossroad Publishing, 1990: 115–45.

Edmunds, Martha Mel. "La Sainte-Baume and the Iconography of Mary Magdalene" in *Gazette des Beaux-Arts* (1989): 11–28.

Elkins, James. *Pictures and Tears: A History of People Who Have Cried in Front of Paintings.* New York: Routledge, 2001.

Emminghausen, Johannes H. *Mary Magdalene: The Saints in Legend and Art.* West Germany: Aurel Bongers Publishers, 1964.

Erhart, Gregor. *Sainte Marie Madeleine.* Paris: Réunion des Musées Nationaux, 1997.

Ferguson, George. *Signs and Symbols in Christian Art.* New York: Oxford University Press, 1980 (1966).

Friedländer, Max J. *Early Netherlandish Painting.* New York: Praeger Publishing, 1967.

Grössinger, Christa. *Picturing Women in Late Medieval and Renaissance Art.* Manchester: University of Manchester Press 1997: 30, 34–35, 39, 59.

Hall, James. *Dictionary of Subjects and Symbols in Art.* New York: Harper and Row, 1979.

Harbison, Craig. "Lucas van Leyden, the Magdalen and the Problem of Secularization in early Sixteenth Century Northern Art" in *Oud Holland* 98 (1984): 117–29.

Haskins, Susan. *Mary Magdalen: myth and metaphor.* New York: Harcourt, Brace & Company, 1994 (1993).

Hollander, Anne. *Seeing through Clothes.* New York: Avon Books, 1975.

Hufstader, Anselm. "Lefèvre d'Étaples and the Magdalen" in *Studies in the Renaissance* 16 (1978): 31–60.

Ingenhoff-Danhäuser, Monika. *Maria Magdalena: Heilige und Sünderin in der italienischen Renaissance.* Tübingen: Ernst Wasmuth Verlag, 1984.

Jameson, Anna Brownell Murphy. *The History of Our Lord as Exemplified in Works of Art.* London: Longmans, Green, and Co., 1872.

Jameson, Anna Brownell Murphy. *Sacred and Legendary Art.* New York: AMS Press, 1970 (1863). 1: 342–81.

Koch, Robert A. "La Sainte-Baume in Flemish Landscape Painting of the Sixteenth Century" in *Gazette des Beaux Arts ser* 6.66 (1965): 273–82.

LaRow, S.S.J., Sister Magdalen. *The Iconography of Mary Magdalen: The Evolution of a Western Tradition until 1300.* Unpublished Ph.D. dissertation, New York University, 1982.

Langmuir, Erika. *Pocket Guides: Saints.* London: The National Gallery, 2001: 51–63.

Mâle, Émile. *Religious Art from the Twelfth to the Eighteenth Centuries.* Princeton: Princeton University Press, 1982 (1949).

Malvern, Marjorie. *Venus in Sackcloth: The Magdalen's Origins and Metamorphoses.* Carbondale: University of Illinois Press, 1975.

Mellinkoff, Ruth. "Three Mysterious Ladies Unmasked" in *Journal of Jewish Art* 10 (1984): 14–28.

Montandon, Alain. *Marie-Madeleine: figure mythique dans la littérature et les art.* Clermont-Ferrand: Presses universitaires Blaise-Pascal, 1999.

Murray, Peter and Linda. *Oxford Companion to Christian Art.* Oxford: Oxford University Press, 1997.

Nead, Lynn. "The Magdalen in modern times: the mythology of the fallen woman in Pre-Raphaelite painting" in *Looking on: Images of femininity in the visual arts and media.* London: Pandora, 1987: 73–92.

Neil, Ketti. "St. Francis of Assisi, The Penitent Magdalen and the Patron at the Foot of the Cross" in *Rutgers Art Review IX–X* (1988–89): 83–110.

Nochlin, Linda. "Lost and Found: Once More the Fallen Woman" in *Art Bulletin* 60.1 (1978): 139–53.

Noireau, Christiane. *Marie-Madeleine.* Paris: Éditions du Regard, 1999.

Panofsky, Erwin. *Early Netherlandish Painting.* New York: Harper and Row, 1971 (1953).

Pardo, Mary. "The Subject of Savoldo's Magdalene" in *Art Bulletin* 71.1 (1989): 67–91.

Réau, Louis. *Iconographie de l'Art Chrétien.* Paris: Presses Universitaire de France, 1957.

Schiller, Gertrud. *Iconography of Christian Art.* London: Lund Humphries Limited, 1971 (1966).

Simson, Otto von. "Compassio and Co-Redemptio in Rogier van der Weyden's Descent from the Cross" in *Art Bulletin* 35.1 (1953): 9–16.

Taylor, Joshua C., Jane Dillenberger, and Richard Murray, *Perceptions and Evocations: The Art of Elihu Vedder.* Washington, D.C.: National Collection of Fine Arts, 1979: 135–36.

Tombu, Jeanne. "Un Triptyque du Maitre de la Legende de Marie-Madeleine" in *Gazette des Beaux-Arts* 69.1 (1927): 299–311.

Ward, John L. "A Proposed Reconstruction of an Altarpiece by Rogier van der Weyden" in *The Art Bulletin* 53.1 (1971): 27–40.

Wilbering, Erick. "Embracing the Cross: A Liturgical Gesture" in *Source: Notes in the History of Art* 8.2 (1989): 1–5.

CINEMA STUDIES

Babington, Bruce and Peter William Evans. *Biblical Epics: Sacred Narrative in the Hollywood Cinema.* Manchester: Manchester University Press, 1993.

Butler, Ivan. *Religion in the Cinema.* New York: A.S. Barnes & Co., 1969.

Campbell, Richard H. and Michael R. Pitts. *The Bible on Film: A Checklist, 1897–1980.* Metuchen: Scarecrow Press, 1981.

DeMille, Cecil. *The Autobiography of Cecil B. DeMille.* Englewood Cliffs: Prentice-Hall, 1959.

Forshey, Gerald E. *American Religious and Biblical Spectaculars.* Westport: Praeger, 1992.

Fraser, Peter. *Images of the Passion: The Sacramental Mode in Film.* Westport: Praeger, 1998.

Kinnard, Roy and Tim Davis. *Divine Images: A History of Jesus on the Screen.* New York: Citadel Press, 1992.

Maltby, Richard. "The King of Kings and the Czar of All the Rushes: story" in *Screen 31.2* (Summer 1990): 188–213.

Smith, Jeffrey A. "Hollywood Theology: The Commodification of Religion in Twentieth-Century Films" in *Religion and American Culture 11.2* (Summer 2001): 191–231.

EXHIBITION CATALOGUES AND SYMPOSIA PROCEEDINGS

L'image de la Madeleine: du XV e qu XIX e siècle: actes du colloque de Fribourg, 31 mai–2 juin 1990. Fribourg: Éditions universitaires, 1996.

Mosco, Marilena. *La Maddalena Tra Sacro e Profano.* Firenze: Casa Usher, 1986.

Marie Madeleine dans la mystique, les arts et les lettres: actes du colloque international, Avignon, 20–21–22 juillet 1988.

LITERARY STUDIES

Garth, Helen M. *Saint Mary Magdalene in Medieval Literature.* Baltimore: Johns Hopkins University Press, 1950.

Pinto-Mathieu, Elisabeth. *Marie-Madeleine dans la littérature du Moyen Âge.* Paris: Beauchesne, 1997.

Young, Karl. *The Drama of the Medieval Church.* Oxford: Clarendon Press, 1951 (1933).

MUSIC HISTORY STUDIES

Bloch, Vitale. "A Luteplayer by Jan van Hemessen" in *Burlington Magazine 98* (1956): 445–47.

Heartz, Daniel. "Mary Magdalen, Lutenist" in *Journal of the Lute Society of America 5* (1972): 52–67.

Rankin, Susan. "Mary Magdalene in the 'Visitatio sepulchri' ceremonies" in *Early Music History I.* Cambridge: Cambridge University Press, 1981; 227–56.

Slim, H. Colin. "Instrumental Versions, c. 1515–1554, of a Late-Fifteenth-Century Flemish Chanson, O Waerde Mont" in *Music in Medieval and Early Modern Europe: Patronage, Sources, and Texts.* Cambridge: Cambridge University Press, 1977; 131–49.

Slim, H. Colin. "Mary Magdalen, mondaine musicale" in *Report of the Twelfth Congress of the International Musicological Society, Berkeley 1977.* Kassel: Bärenreiter-Verlag, 1981: 816–24.

Slim, H. Colin. "Mary Magdalene, musician and dancer" in *Early Music* (October 1980): 460–73.

Slim, H. Colin. "Paintings of Lady Concerts and the Transmission of 'Jouissance vous donneray'" in *Imago Musicae I* (1984): 51–73.

Szövérffy, Joseph. "'Peccatrix Quondam Femina': A Survey of the Mary Magdalen Hymns," *Traditio 19* (1963): 79–146.

RELIGIOUS STUDIES

Atwood, Richard. Mary Magdalene in the *New Testament Gospels and Early Tradition.* New York: Peter Lang Publishing, 1993.

Boer, Esther de. *Mary Magdalene: Beyond the Myth.* Harrisburg: Trinity Press International, 1997.

Bruckberger, Raymond-Léopold. *Mary Magdalene.* New York: Pantheon, 1953.

Brevarium Romanum, 1952.

Calendarium Romanum. Vatican: Typis Polygottis Vaticanis, 1969.

Divine Liturgy of St. John Chrysostom of the Eastern Orthodox Church. New York: Greek Orthodox Archdiocese of North and South America, 1969.

Eisen, Ute E. *Women Officeholders in Early Christianity.* Collegeville: Liturgical Press, 2000.

Getty-Sullivan, Mary Ann. *Women in the New Testament.* Collegeville: Liturgical Press, 2001: 182–218.

Greek Orthodox Holy Week and Easter Services. Daytona Beach: Patmos Press, 1979.

Greek Orthodox Holy Week and Easter Services. Brookline: Narthex Press, 1994.

Jansen, Katherine Ludwig. *The Making of the Magdalen: preaching and popular devotion in the later Middle Ages.* Princeton: Princeton University Press, 2000.

Ketter, Peter. *The Magdalene Question.* Milwaukee: Bruce Publishing Company, 1935.

Lamberstein, Isaac E. *The life of the holy myrrh-bearer and equal to the apostles Mary Magdalene.* Liberty: St. John of Kronstadt Press, 1988 (1985).

Lenten Liturgies. Northridge: Narthex Press, 1995.

Maisch, Ingrid. *Mary Magdalene: The Image of a Woman Through the Centuries.* Collegeville: Liturgical Press, 1998.

Marjanen, Antti. *The Woman Jesus Loved: Mary Magdalene in the Nag Hammadi Library and Related Documents.* Leiden: Brill Academic Publishers, 1996.

"Mary Magdalene" in *Jerome Bible Commentary.* Englewood Cliffs: Prentice-Hall, Inc., 1968: 59–60, 138, 462.

"Mary Magdalene" in *Interpreter's Bible.* New York: Abingdon-Cokesbury Press, 1951–57.

"Mary Magdalene" in *New Schaff-Herzog Encyclopedia of Religious Knowledge.* Grand Rapids: Baker Book House, 1956. 7: 225.

"Mary Magdalene" in *Oxford Dictionary of Byzantium.* New York: Oxford University Press, 1991. 2: 1310.

"Mary Magdalene" in *New Catholic Encyclopedia.* New York: McGraw Hill, 1967. 9: 387–89.

"Mary Magdalene" in *Encyclopedia of Women and World Religions.* New York: Macmillan Reference, 1999. 2: 631–33.

"St. Mary Magdalene" in *Butler's Lives of the Saints.* New York: P.J. Kennedy and Son, 1962. 3:161–63.

"Mary, 3. Mary Magdalene" in *New Westminister Dictionary of the Bible.* Philadelphia: Westminister Press, 1970: 594.

"Mary, 3. Mary Magdalene" in *Harper's Bible Dictionary.* San Francisco: Harper and Row, 1985.

"Mary Magdalene" in *Oxford Companion to the Bible.* New York: Oxford University Press, 1993: 499.

"Mary, 3. Mary Magdalene" in *Dictionary of the Bible.* New York: Scribners, 1963 revised ed.: 628–29.

"Mary, 2. Mary Magdalene" in *New Standard Bible Dictionary.* New York: Funk and Wagnall, 1936, 3rd revised ed.: 558–59.

Poulos, George. *Orthodox Saints.* Brookline: Holy Cross Orthodox Press, 1991.

Quenot, Michel. *The Resurrection and the Icon.* Crestwood: St. Vladimir's Seminary Press, 1997.

Ricci, Carla. *Mary Magdalene and Many Others: Women Who Followed Jesus.* Minneapolis: Fortress Press, 1994

Roman Breviary. New York: Benzinger Brothers, 1950.

Roman Calendar: Text and Commentary. Washington, D.C.: United States Catholic Conference, 1976.

Roman Missal: The Lectionary for the Mass. New York: Catholic Book Publications, 1970.

Roman Missal: The Sacramentary. New York: Catholic Book Publications, 1970.

Saxer, Victor. *La Culte de Marie Madeleine en Occident des origines à le fin du moyen âge.* Paris: Librarie Claveuil, 1959.

Services for Holy Week and Easter. Northridge: Narthex Press, 1999.

Shuger, Debora Kuller. *Renaissance Bible: Scholarship. Sacrifice, and Subjectivity.* Berkeley: University of California Press, 1994.

Stablig, Thomas and Silvia Schroer. *Body Symbolism in the Bible.* Collegeville: Liturgical Press, 2001.

Starbird, Margaret. *The Woman with the Alabaster Jar: Mary Magdalen and the Holy Grail.* Santa Fe: Bear and Company Publishers, 1993.

Thompson, Mary R. *Mary of Magdala: Apostle and Leader.* New York: Paulist Press, 1995.

WOMEN'S STUDIES

Bainton, Roland H. *Women of the Reformation in Germany and Italy.* Minneapolis: Augsburg Publishing House, 1971.

Bell, Susan Groag. "Medieval Women Book Owners. Arbiters of Lay Piety and Ambassadors of Culture" in *Signs* 7.4 (1982): 173–84.

Dijkstra, Bram. Idols of Perversity. *Fantasies of Feminine Evil in Fin-de-Siecle Culture.* New York: Oxford University Press, 1986.

Gottlieb, Beatrice. "The Problem of Feminism in the Fifteenth Century" in *Women of the Medieval World.* Oxford and New York: Basil Blackwell, 1985: 337–64.

Levy, Janey L. "Popular Culture and Early Lutheran Iconography in the Early Sixteenth Century" in *Rutgers Art Review* 6 (1985): 35–54.

McNamara, Jo Ann. "Sexual Equality and the Cult of Virginity in Early Christian Thought" in *Feminist Studies* 3.3/4 (1976): 145–58.

Miles, Margaret R. *Carnal Knowing. Female Nakedness and Religious Meaning in the Christian West.* Boston: Beacon Press, 1989.

Miles, Margaret R. *Carnal Knowing. Image as Insight: Visual Understanding in Western Christianity and Secular Culture.* Boston: Beacon Press, 1985.

Moltmann-Wendel, Elisabeth. *The Women Around Jesus.* New York: Crossroad Publishing, 1982.

Mullins, Edwin. *The Painted Witch. Female Body/Male Art.* London: Secker and Warburg, 1985.

Powers, Eileen. *Medieval Women.* Cambridge: Cambridge University Press, 1979 (1975).

Ruether, Rosemary Radford. *Religion and Sexism. Images of Woman in the Jewish and Christian Traditions.* New York: Simon and Schuster, 1974.

Schussler Fiorenza, Elizabeth. *In Memory of Her.* New York: Crossroad Publishing, 1983.

Scott, Joan W. "Gender: A Useful Category of Historical Analysis" in *American Historical Review* 91.5 (1986): 1053–75.

Walker, Barbara G. *Woman's Encyclopedia of Myths and Secrets.* San Francisco: Harper and Row, 1983.

Wiesner, Merry E. "Beyond Women and the Family: Towards A Gender Analysis of the Reformation" in *Sixteenth Century Journal* 18.3 (1987): 311–22.

Illustrations

FRONT COVER

Carlo Dolci (Italian, 1616–1687)
The Penitent Magdalen, c. 1670 (detail)
Oil on canvas
Museum Purchase, 1958.19
Davis Museum and Cultural Center,
Wellesley College, Wellesley, MA

BACK COVER

Gustave Doré (French, 1832–1883)
Woman Taken in Adultery (detail)
From *The Doré Bible Gallery*
New York: Fine Art Publishing Co., 1879
The Library at the American Bible Society

FIGURES IN ESSAY AND ENTRIES

1 Magdalene Master (13th century)
La Maddelena e Storie della Sua Vita
Copyright Scala/Art Resource, NY
Accademia, Florence, Italy

2 *Mary Magdalene Healed by Christ*
Book of Hours, France, 1460–1470
The Pierpont Morgan Library, New York
MS M. 54 f. 18.

3 *Mary Magdalene Holding a Red Egg*
20th century, Icon
Courtesy of Holy Transfiguration Monastery
Brookline, MA

4 Enguerrand Quarton (French, 1410–c. 1464)
The Avignon Pietà
Copyright Erich Lessing/Art Resource, NY
Louvre, Paris, France

5 Fra Angelico (Italian, 1387–1455)
Crucifixion
Copyright Scala/Art Resource, NY
Museo di San Marco, Florence, Italy

6 Master of Virgo Inter Virgines (active c. 1470–1500)
Crucifixion
Copyright Scala/Art Resource, NY
Uffizi, Florence, Italy

7 Martin Schongauer (German, 1435–1491)
Noli Me Tangere, c. 1470–1480
Oil on wood
Musée Unterlinden, Colmar, France

8 Master of the Magdalene Legend
Saint Mary Magdalene Preaching, c. 1500–20
Oil on panel
John G. Johnson Collection
Philadelphia Museum of Art, J No. 402

9 Rogier van der Weyden (Dutch, 1399/1400–1464)
The Magdalen Reading
Copyright Alinari/Art Resource, NY
National Gallery, London, Great Britain

10 Michelangelo Merisi da Caravaggio (Italian, 1573–1610)
Penitent Magdalene
Copyright Scala/Art Resource, NY
Galleria Doria Pamphili, Rome, Italy

11 Jean Béraud (French, 1849–1936)
Mary Magdalen at the House of the Pharisee, 1891
Copyright Erich Lessing/Art Resource, NY
Musée d'Orsay, Paris, France

12 Pablo Ruiz Picasso (Spanish, 1881–1973)
Weeping Woman, 1937
Drawing
Courtesy of the Fogg Art Museum, Harvard University
Art Museums, Francis H. Burr Memorial Fund

13 Gustave Doré (French, 1832–1883)
Woman Taken in Adultery
From *The Doré Bible Gallery*
New York: Fine Art Publishing Co., 1879
The Library at the American Bible Society

14 Adriaen Isenbrant (Flemish, c. 1500–1551)
The Penitent Magdalen, undated
Oil on panel
Gift of Mrs. Berry v. Stoll, 1967.22
Collection of The Speed Art Museum, Louisville, Kentucky

15 Albrecht Dürer (German, 1471–1528)
Mary Magdalene Carried to Heaven, 1504–1505
Woodcut
The Art Museum, Princeton University
Gift of Frank Jewett Mather, Jr., x1935-1468

16 Carlo Dolci (Italian, 1616–1687)
The Penitent Magdalen, c. 1670
Oil on canvas
Museum Purchase, 1958.19
Davis Museum and Cultural Center
Wellesley College, Wellesley, MA

17 Elihu Vedder
The Magdalen, 1883–1884 (Illustration for Rubáiyát of
Omar Khayyám)
Chalk, pencil and ink on paper
1978.108.42, Museum purchase and gift from Elizabeth W.
Henderson in memory of her husband Francis Tracy
Henderson. Smithsonian American Art Museum,
Washington, DC/Art Resource, NY

18 *The Myrrhbearing Women at the Tomb*, Russian, 16th century
Courtesy of St. Vladimir's Seminary Press, Crestwood, NY

19 *Raising of Lazarus* and *Noli Me Tangere*
Gothic casket, Italian, last quarter of 14th century
Wood, gesso, polychrome
Collection Michael Hall Esq.

20 Watanabe Sadao (Japanese, 1914–1996)
The Raising of Lazarus, 1981
Katazome stencil print
From the collection of Anne H.H. Pyle
Courtesy of Ms. Harue Watanabe

21 Wendy Brusick Steiner (American, b. 1956)
I've Seen Love Conquer the Great Divide, 1989
Oil on canvas
Sloan Fund Purchase/Anonymous Friends Purchase
Brauer Museum of Arts, 89.24
Valparaiso University

22 Master of the Parrot (Flemish)
Portrait of a Noble Lady Reading her Prayer Book, c.1520
Oil on panel
Collection of the Zanesville Art Center

23 *Magdalene Holding a Jar*, German, 19th century
Wood
The Frances Lehman Loeb Art Center
Vassar College, Poughkeepsie, New York
Gift of Mrs. Felix M. Warburg and her children, 1941.1.145

24 After Correggio (c. 1775–1825)
Saint Magdalen Reading
Oil on canvas
Collection of The New-York Historical Society, 1858.54

25 Lucas van Leyden (Dutch, 1494–1533)
Dance of St. Mary Magdalene, 1519
Engraving
Gift of Mrs. Toivo Laminan (Margaret Chamberlin,
Class of 1929), 1961.1
Davis Museum and Cultural Center
Wellesley College, Wellesley, MA

26 Book jacket for *The Galileans* by Frank G. Slaughter, 1953
Doubleday, a division of Random House, Inc.
Illustration by Franz Felix

SINNER

The Rebuked
From *Godey's Lady's Book*
June 1844
10½ x 7 in. (closed)
American Antiquarian Society, MA

Léopold Flameng (French, 1831–1911)
Savé (la femme adulteré), 1861
Print
4 x 18 in.
From the Collection of Donna M. and Mark H. Moran

Gustave Doré (French, 1832–1883)
Woman Taken in Adultery
12 x 10 x 1 in. (closed)
From *The Doré Bible Gallery*
New York: Fine Art Publishing Co., 1879
The Library at the American Bible Society

Mary Magdalene Before, and After Her Conversion
from J. James Tissot *The Life of Our Lord Jesus Christ*
New York: McClure-Tissot Co., 1899 (copyright 1895)
13¾ x 11 x 1¾ in. (closed)
The Library at the American Bible Society

Ruth Dunkell (American)
Mary Magdalene Out of Whom He Had Cast Seven Devils, 2001
Drawing
25 x 18 in.
Collection of the Artist

PENITENT

Albrecht Dürer (German, 1471–1528)
Mary Magdalene Carried to Heaven, 1504–1505
Woodcut
21.2 x 14.4 cm (trimmed to plate)
The Art Museum, Princeton University
Gift of Frank Jewett Mather, Jr., x1935-1468

Adriaen Isenbrant (Flemish, c. 1500–1551)
The Penitent Magdalen, undated
Oil on panel
9 x 6¼ in.
Gift of Mrs. Berry v. Stoll, 1967.22
Collection of The Speed Art Museum, Louisville, Kentucky

Carlo Dolci (Italian, 1616–1687)
The Penitent Magdalen, c. 1670
Oil on canvas
25½ x 20 in.
Davis Museum and Cultural Center, Wellesley College,
Wellesley, MA
Museum Purchase, 1958.19

Penitent Magdalene, Augsburg, 17th century
Bronze plaquette
4½ x 3¾ in.
Collection Michael Hall Esq.

After Guido Reni (Italian, 1575–1642)
Penitent Magdalene, 17th century
Oval plaquette, watercolor and gouache on vellum
3½ x 4½ in.
Collection Michael Hall Esq.

Matìas de Torres (Spanish, 1631/35–1711)
The Penitent Mary Magdalene, 1680
Drawing
On loan from The Hispanic Society of America, New York, LA418

Antonio Canova (Italian, 1757–1822)
Penitent Magdalene, 1780s
Terracotta
9 x 3 in.
Collection Michael Hall Esq.

Mary Magdalene
Bible in English. Worcester, MA: Isaiah Thomas, 1791
16 x 10¼ x 2¼ in. (closed)
The Library at the American Bible Society

The Magdalen
Rubáiyát of Omar Khayyám (First Edition), 1883–1884
With illustrations by Elihu Vedder
Lauinger Library, Georgetown University
Washington, D.C.

Gustave Doré (French, 1832–1883)
Mary Magdalene Penitent
From *The Doré Bible Gallery*, Philadelphia: Henry Altemus, c. 1890
12 x 10 x 1 in. (closed)
The Library at the American Bible Society

After Michelangelo Merisi da Caravaggio (Italian, 1573–1610)
The Penitent Magdalene, 19th century (?)
Oil on canvas
39 x 30 in.
Church of St. John the Evangelist, Newport, RI

After Carlo Dolci (Italian, 1616–1686)
The Penitent Magdalene, 19th century (?)
Oil on canvas
18 x 24 in.
Church of St. John the Evangelist, Newport, RI

Watanabe Sadao (Japanese, 1914–1996)
His Feet Were Wet with Her Tears, 1970
Katazome stencil print
23 x 27 in.
From the collection of Anne H.H. Pyle

WITNESS

Resurrection of Lazarus and *Noli Me Tangere*
Italian, last quarter of 14th century
Gothic casket
Wood, gesso, polychrome
12 x 13 x 6 in.
Collection Michael Hall Esq.

Galleazzo Mondella called
Moderno (Italian, 1467?–1528/29)
Crucifixion, ca. 1506
Gilt bronze plaquette
4½ x 3 in.
Collection Michael Hall Esq.

Barend van Orley (Flemish, 1491–1542)
Mourning Over Christ, undated
Oil on panel
10 x 7¼ in.
Collection of The Speed Art Museum, Louisville, Kentucky
Museum Purchase, 1967.23

Lamentation, 16th century
Palissey: 8 x 10 in.
Leather: 8 x 11 in.
Bronze: 8 x 11 in.
Collection Michael Hall Esq.

Related to Gian Federigo Bonzagna, called Parmense
(Italian, active 1547–75)
Entombment, 1560s
Gilt bronze
6 x 5 in.
Collection Michael Hall Esq.

Entombment, c. 1580, Italian (?)
Bronze plaquette
9⅓ x 7⅓ in.
Collection Michael Hall Esq.

Agostino Carracci (Italian, 1557–1602)
Crucifixion, 1582
Woodcut (after Paolo Veronese, 1528–1588)
12 x 8¾ in.
Collection of Sandra and Robert Bowden

*Mary Magdalene with the Other Holy Women at the Empty Tomb and with
the Resurrected Christ*
Hieronymus Natali (Geronimo Nadal)
Evangelicae Historiae Imagines
Antwerp: Martinus Nutius, 1596
12¾ 9 x 1½ in. (closed)
Library at the American Bible Society

School of Rembrandt van Rijn (Dutch 1600-1667)
Noli Me Tangere, mid 17th century
8 x 10 in.
Pen and brown ink
Collection Michael Hall Esq.

Noli Me Tangere and *Angels and Women at the Empty Tomb*
Melchior Kysel. Icones Biblicae Veteris et Novi Testamenti
Augsburg, 1679
8½ x 7½ 1¾ in. (closed)
Library of the American Bible Society

Giocomo Parolini (Italian, 1663–1733)
Noli Me Tangere, undated
Etching
4⅛ x 2¹/₁₆ in.
Collection of Sandra and Robert Bowden

After Bartolomaeus Spranger (Dutch, 1546–1611)
Three Maries at the Tomb, 18th century
Engraving
19½ x 13 in.
Collection of Michael Hall Esq.

Crucifixion
Bible in Norwegian
Chicago, IL: N. Juul and Co., c. 1889
12 x 11 x 5 in.
Library of the American Bible Society

Jules Chadel (French, 1870–1941)
At the Tomb, 1932
Drawing
8¾ x 12¾
Collection of Sandra and Robert Bowden

The Myrrhbearing Women, early 20th century
Icon
Oil on wood
16½ x 15½ in.
The Hollingsworth Collection, H6

Watanabe Sadao (Japanese, 1914–1996)
The Raising of Lazarus, 1981
Katazome stencil print
26½ x 22½ in.
From the collection of Anne H.H. Pyle

Watanabe Sadao (Japanese, 1914–1996)
The Women at the Sepulchre, 1967
13¼ x 9 in.
Katazome stencil print
Collection Ute Schmid

Wendy Brusick Steiner (American, b. 1956)
I've Seen Love Conquer the Great Divide, 1989
Oil on canvas
72¼ x 96 in.
Sloan Fund Purchase/Anonymous FRIENDS Purchase
Brauer Museum of Arts, 89.24
Valparaiso University

Ellen McGuckin
St. Mary Magdalene, 2000
Gessoed canvas on board; gold leaf background
20 x 16 in.
Private collection

Ruth Dunkell (American)
And They Say unto Her, Woman Why Weepest Thou, 2001
Drawing
25 x 18 in.
Collection of the Artist

Dmitri Andreyev (Russian-American, b. 1964)
Myrrhbearing Women, 2002
Tempera; gold leaf on wood panel
18 x 24 in.
Collection of the Artist

CONTEMPLATIVE

Master of the Parrot (Flemish)
Portrait of a Noble Lady Reading her Prayer Book, c. 1520
Oil on panel
14½ x 20 in.
Collection of the Zanesville Art Center

Penitent Magdalene Reading in the Wilderness, Early 16th century
No. 1 (Volume) Book of Hours (Bourges), Ms. 33
Lessing J. Rosenwald Collection
Rare Book & Special Collections Division
Library of Congress, Washington, D.C.

After Antonio Allegri Correggio (Italian, c. 1775–1825)
Saint Magdelen Reading
Oil on canvas
18 x 14 in.
Lent by The New-York Historical Society, New York, 1858.54

Martha
Paul Wright. *The New and Complete Life of Our Blessed Lord and Savior Jesus Christ*
New York: William Durell, 1803 (?)
12½ x 8¼ in. (closed)
American Antiquarian Society, MA

Mary Magdalene by Pompeo Girolamo Batoni
From *Woman in Sacred History*, Harriet Beecher Stowe
New York, J.B. Ford and Company, 1873
12 x 9½ x 2¼ in. (closed)
American Antiquarian Society, Worcester, MA

Martha
From *The Women of the Scriptures*, edited by Rev. H. Hastings Weld
Philadelphia: Lindsay and Blakiston, 1848
9½ x 6½ in. (closed)
American Antiquarian Society, Worcester, MA

Correggio's *Magdalen Reading*
Gem of the Season. New York: Published by Leavitt & Allen, 1856.
9¾ x 7¼ in. (closed)
American Antiquarian Society, Worcester, MA

Gustave Doré
Mary and Martha
Bible in English. London and New York
Cassell, Petter, and Galpin, c. 1869
15¼ x 12½ x 3¾ (closed)
The Library at the American Bible Society

Magdalene Holding a Jar, German, 19th century
Wood
28½ in. high
Frances Lehman Loeb Art Center
Vassar College, Poughkeepsie, NY
Gift of Mrs. Felix M. Warburg and her children, 1941.1.145

Jim Rosen (American)
Magdalene, 1989
Watercolor/gouache
24 x 19¾ in.
From the collection of Betty Wallace Sivas and the late
Dr. Richard S.Wallace, (June 24, 1934 – July 20, 1991)
in his memory.

MUSE

Lucas van Leyden (Dutch, 1494–1533)
Dance of St. Mary Magdalene, 1519
Engraving
Sheet: 11⅝ x 15¹¹⁄₁₆ in.
Davis Museum and Cultural Center
Wellesley College, Wellesley, MA
Gift of Mrs. Toivo Laminan (Margaret Chamberlin,
Class of 1929), 1961.1

Magdalene Receiving Pilgrims at Her Cave
Early 20th century
Facsimile of Illuminated Manuscript
9¼ x 7 in.
Private Collection, New York

POP CULTURE ITEMS

Film Stills
Courtesy of the Museum of Modern Art, New York:

Jesus at the Home of Mary and Martha from
From the Manger to the Cross (1912)

Accused of adultery Mary Magdalene alone on the steps
from *The Judean Story in Intolerance* (1916)

Mary Magdalene at the Doorway from *The Eternal Magdalene* (1919)

Mary Magdalene on the banquet couch
from *The King of Kings* (1927)

Mary Magdalene washing the feet of Jesus
from *The King of Kings* (1927)

Mary Magdalene at the foot of the Cross
from *The King of Kings* (1927)

Mary Magdalene washing the feet of Jesus
from *Day of Triumph* (1954)

Mary Magdalene mourning the dead Jesus
from *Celui Qui Doit Mourir (He Who Must Die)* (1956)

Mary Magdalene alone at the wall from *The King of Kings* (1961)

Mary Magdalene being chased by her accusers from *The King of Kings* (1961)

Photo courtesy of The Melina Mercouri Foundation:

Melina Mercouri as Mary Magdalene in *Celui Qui Doit Mourir (He Who Must Die)* (1956)

Poster

Movie poster for *Mary Magdalene*, starring Yvonne de Carlo, copyright © 1960 AMEX Productions, Inc.

Books

Illustrated Movie Souvenir Book for *Jesus Christ Superstar*, Souvenir Book Publishers, Inc., New York: New York, 1973.

Book Jacket from *The Magdalene Woman*, Margaret Rogers, New York: St. Martin's Press, 1980. The cover reproduces *The Repentant Magdalen* by Georges de La Tour (1593–1652).

Book Jacket for *A Certain Woman: The Story of Mary Magdalene*, Victor MacClure, New York: Pelligrini & Cudahy, 1951. Illustration by Edward Meshekoff.

Book Cover Illustration for *The Galileans*, Frank G. Slaughter, Montreal: Permabooks, 1957. Illustration by Robert Schulz.

Book Jacket for *The Galileans*, Frank G. Slaughter, New York: Doubleday & Co., Inc. 1953. Illustration by Franz Felix.

Book Jacket for *The Scarlet Lily*, Edward F. Murphy, Milwaukee: The Bruce Publishing Company, 1944.

Book Jacket for *Road from Olivet*, Milwaukee: The Bruce Publishing Company, 1946.

Book Cover for *The Secret of Mary Magdalene*, Paul Ilton, New York: The New American Library of World Literature, Inc. 1956. Illustration by James Avanti.

Behold the Man: The Story of Mary Magdalene and Judas Iscariot, N. Richard Nash, New York: Doubleday & Co., 1986.

Movie Production Book for *King of Kings*, Metro-Goldwyn-Mayer and Samuel Bronston Productions, Inc., 1961.

CD Covers

Salve Regina by Marc-Antoine Charpentier. Copyright: harmonia mundi s.a.

La Magdalena. Lute Music in Renaissance France by Christopher Wilson. Copyright: 1995 Virgin Classics Limited.

Sacred Women. Women as Composers and Performers of Medieval Chant by Sarband. Copyright: 2001 Dorian Recordings.

Between Two Hearts. Renaissance Dances for Lute by Ronn McFarlane. Copyright: 1996 Dorian Recordings.

J'ay pris Amours. Chansons au luth du XVIème siècle by Claudine Ansermet and Paolo Cherici. Copyright: 1999 Symphonia.

Historiae, The Offices of St. Lawrence's and Mary Magdalene's, Gregorian Chants by Schola Hungarica. Copyright: 1998 Hungaroton Records Ltd.